EGYPTIAN CARPETS

EGYPTIAN CARPETS
A Practical Guide

by
Luanne Brown
Sidna Rachid

THE AMERICAN UNIVERSITY IN CAIRO PRESS

Dar el Kutub no. 4535/85
ISBN 977-424-057-X

Printed by the American University in Cairo Press

Contents

List of Plates

List of Figures

Preface

We were surprised, as many long-time residents of Egypt are, to discover that this country has a thriving carpet industry. As we started looking at Egyptian carpets we were impressed by what we saw.

Because very little is written on the carpet industry in Egypt, old or new, our research entailed interviewing the major carpet producers as well as people working in supporting industries such as wool. We started with more questions than answers and are indebted to the patience and good will of the many people we interviewed. We were impressed by their dedication to making a product they could take pride in.

Everyone we talked to encouraged us in our venture, but there are a few people we would like to thank especially: Dr. John Rodenbeck, former Director of the AUC Press; Engineer Aly Khattab and Mr. Galal Farghali, Misr Beida Dyers Company; Dr. Mohamed Tawfik and Dr. Brian Harrop, International Wool Secretariat; Hisham Shehata, Department of Agriculture; and Mary Barzee.

The following carpet manufacturers devoted a lot of time to talking with us about the carpet industry as a whole and allowed us to photograph their rugs and factories: Loutfi Moustafa of Loutfi Moustafa and Sons, Alexandria; Abdallah el Kahhal of El Kahhal, Cairo; Hussein Alfi of Kelim, Cairo; and the staff at the Masged el Hadeya, Alexandria.

We would also like to thank Vimal Advani who created the illustrations for this book. The drawings were inked by Nazli Maurice Khoury.

1 An Introduction to Egyptian Carpets

Egypt is an exciting but confusing country to many visitors. The crowded streets filled with cars, horse-drawn carts, buses, and people can be a challenge to navigate. The lack of a common language can make communication difficult. Shopping for a carpet under these conditions is not as easy as shopping for one in your home town. It requires knowledge of the hidden costs of buying a carpet abroad, and preparation so that you will know what to look for and where to go. Patience and a sense of humor help, too.

By reading this book, you will become familiar with the types of carpets available in Egypt, how they are made, and how to distinguish the characteristics of a good quality carpet. Another important feature of this guide is the location of many carpet shops in Alexandria and Cairo and the type of carpets they sell.

In this book, an Egyptian carpet is defined as any carpet made by hand in Egypt. This includes a large range of rugs, and no matter what your budget or your tastes, you can find one that is right for you.

Egyptian carpets can be classified into two broad categories, flat woven and pile.

Flat Woven Carpets

Flat woven carpets are woven like fabric and have no pile. Because they can be produced quickly, they are relatively inexpensive. Below is a brief description of each type of flat woven rug produced in Egypt.

Kilims. There are two types of Egyptian kilims, Helwan and Assyuti. Helwan kilims are woven in natural colors of wool ranging from cream to dark brown with geometrical patterns. These carpets are becoming popular in Europe and are an excellent value. Assyuti kilims are woven in bright or natural colors with traditional designs.

Tapestries. Tapestries are used as wall hangings rather than as carpets. They portray Egyptian rural scenes in a vibrant, colorful style (see plates 22 and 25).

Rag Rugs. Rag rugs are made with scraps of material and are similar to those produced in many other countries. They are woven in solid colors, brightly colored stripes or checkerboard designs and are very inexpensive (see plate 21).

Bedouin Rugs. These carpets are not produced in workshops but in the homes of Bedouins, formerly nomadic people living in the desert regions of Egypt. The carpets are usually brightly colored in reds, purples, and golds. They are woven in pieces, two feet wide and six feet long, which are sometimes sewn together to make a wider rug. The most frequent pattern is stripes on a contrasting background.

Beni Adi Rugs. These rugs are woven by women living around Beni Adi, a small village in Upper Egypt. They are distinctive rugs woven in natural colors of wool with geometrical patterns.

Pile Carpets

Pile carpets are often referred to as Oriental carpets. Most people associate them with Persia although they are made in many other countries, including Egypt. These carpets are more accurately termed "hand-knotted", since each tuft of pile represents a knot which has been individually tied to a base of cotton, wool or silk threads. They are the most elaborate and expensive rugs made in Egypt. Most of the designs are taken from Persian, Turkish, and Caucasian rugs. In Egypt, you can buy an Oriental carpet exactly like one produced in Iran, Turkey, or the Caucasus for less than its cost in the United States or Europe (see plates 24, 28, and 29).

Machine-Made Carpets

Although this guide deals with hand-made carpets it is appropriate to mention Egyptian machine-made carpets.

There are four modern factories in Egypt which produce pile area rugs with Oriental designs. These rugs are a good alternative for anyone who finds the hand-knotted carpets too expensive. They are displayed in many shops that sell wall-to-wall carpeting. The price is controlled by the Egyptian government and the quality is good.

The Development of Carpet Making in Egypt

Unlike Persian carpets, whose reputation has been built on centuries of production, Egyptian carpets are not well known in Europe and the United States. This is because Egypt's carpet industry is relatively young. There are some interesting reasons dating back thousands of years which explain why a large carpet industry did not develop in Egypt until recent times.

Ancient and Pharaonic Periods. The use of carpets evolved from a need to cover the earthen floors of dwellings in ancient times. Climate played an important role in determining the type of floor covering used. In the cold, mountainous regions of Persia, Asia Minor and the Caucasus, where warmth was essential, the first floor coverings were probably animal pelts. In contrast to these colder climates, ground coverings in warmer regions were loose, dried grass or rushes. They were first plaited and later woven into mats.

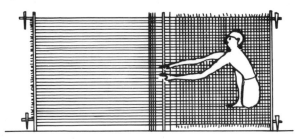

Fig. 1. Mat weaver from the Tomb of Khety, Beni Hassan (circa 1900 B.C.).

Ancient Egyptian society used mats woven from rushes for floor coverings. Rushes grew abundantly along the banks of the Nile and were easily prepared for weaving. Rush mats dating to 5000 B.C. have been found in Egyptian Badarian graves.

Wool also played an important role in the evolution of carpet making. With the development of weaving, the nomadic shepherds living in colder climates used wool to make carpets which provided a warm, easily portable covering for the floor of their tents. Over the centuries, carpet weaving in these areas developed into an art.

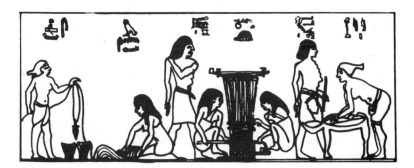

Fig. 2. Tomb painting from a tomb in Beni Hassan which illustrates weaving during the Pharaonic period (circa 1900 B.C.).

3

The use of wool was not popular in Egypt until the Ptolemaic period around 323 B.C.. Although wool was available before this, the priests felt that it was ritually unclean, and wool items were not allowed to be brought into temples or to be buried in graves.

The Ptolemaic Period. Wool was the most important textile in ancient Greece, and when the Greeks and Macedonians occupied Egypt they brought with them wool garments, rugs and mattresses. Throughout the Ptolemaic era the wool industry in Egypt expanded. New species of sheep were introduced and better breeding practices were followed. The Pharaohs and other nobles had personal flocks of sheep to supply them with wool. Flat woven tapestries and carpets were produced and used in Egypt during this period. Floor mosaics of Alexandrian homes imitated the designs of these rugs and some excellent examples of these mosaics are displayed in the Graeco-Roman Museum in Alexandria.

The Coptic Period. During the Coptic period religion in Egypt changed and burial customs changed with it. Bodies were no longer mummified, and some were wrapped in tapestries. Because of this new burial custom, many samples of tapestries have survived from the fourth century and later.

The use of wool for weaving tapestries and flat woven carpets continued through the early Christian era, when the textile industry flourished. Many samples of skillfully woven tapestries, featuring characteristic Coptic designs composed of vines, animals, birds and stylized human forms have survived. Some of these can be seen in the Coptic museum in Cairo.

The Copts also wove heavy fabrics which must have originally been used as rugs or wall hangings. Their manufacture was continued by the Arabs and a few samples of these later fabrics have survived.

Rug fragments that have been found indicate that both cut pile and hand-knotted carpets were produced during the Christian era in Upper Egypt and in the Fayyum, an oasis south of Cairo.

The Moslem Period. After the Moslem occupation of Egypt in 641 A.D., Cairo became a major commercial center of the expanding Islamic Empire. The trade routes passing through Cairo made imported carpets available. Several fragments of imported rugs dating from the ninth century and later have been found in excavations at Fustat, the oldest Moslem settlement in Egypt.

During this period, Egypt not only imported rugs, but also produced heavy wool tapestries which were used as floor coverings. Some were Arabic adaptations of Coptic designs while others were totally Arabic in style. They were of excellent quality and were probably produced for the Egyptian upper classes or for exportation.

The Mamluk Period. It was not until the reign of the Mamluks, during the fifteenth and sixteenth centuries, that fine hand-knotted carpets were produced in Cairo and frequently exported. Confusion arose about the origin of these Mamluk carpets because they were referred to as "Damascus carpets" in inventories of fifteenth century Venetian households. For this reason they were thought to have been woven in Damascus, but there is no evidence that carpets were produced in Syria during this period. Only in the 1920s did carpet experts on the basis of historical references dating from 1474 to a carpet industry in Cairo, identify Cairo as the source of these carpets.

Fig. 3. A simplified motif used in the Mamluk carpets.

The term "Damascus carpet" is now believed to refer to the damask-like effect of the Mamluk carpet designs. These were striking geometrical patterns in red, blue, green and yellow. One carpet expert suggests that these designs were based on the geometrical patterns found in elaborate mosaic fountains, which were common in the homes of the

upper class during this period. Both the Islamic Museum and the Gayer-Anderson House have well preserved fountains of this type.

Why this carpet industry which produced fine hand-knotted carpets suddenly arose in Egypt is puzzling. One scholar feels that the Mamluk rulers, most of whom came from Turkey, produced rugs with Egyptian designs to bolster a poor economy by creating an exportable item.

You can see an example of a Mamluk carpet on the second floor of the Islamic Museum in Cairo.

The Ottoman Period. The Mamluk carpets were still being woven when the Turks conquered Egypt and made it part of the Ottoman Empire in 1517. Turkish floral designs soon appeared in the carpets still being made in Cairo, and in 1585, the Turkish sultan had eleven weavers and four thousand pounds of wool sent to Constantinople, to work directly for him.

In the middle of the seventeenth century, the Egyptian textile and rug industry declined to a level of insignificance, and it was no longer mentioned in literature from that period. Rough flat woven rugs were produced for the local population but imports probably satisfied whatever demand existed for fine hand-knotted carpets.

The Nineteenth Century. The use of prayer rugs in Egypt was well established when E.W. Lane wrote *Manners and Customs of the Modern Egyptians* in 1836. There was a status attached to these rugs and they were probably hand-knotted carpets imported from Turkey and Persia by the carpet merchants in Khan el Khalili, which is still the bazaar area today. Lane also mentions that wool rugs were used in wealthy households during the winter. These were probably imported.

During the nineteenth century, technical schools were opened in Egypt to teach a variety of crafts, including carpet making, and the graduates wove flat woven carpets for the local population.

The Twentieth Century. Trade schools continued to train carpet weavers and new schools were started during the 1920s and 1930s. Graduates of these schools wove carpets for the local market. However, most of the finer hand-knotted carpets sold in Egypt were still being imported, predominantly from Persia.

After the 1952 Revolution, under the Nasser regime, the importation of many items, including carpets, was restricted in an effort to balance Egypt's growing trade deficit. Since carpet dealers were no longer able to acquire carpets made outside Egypt, they could either begin to produce their own carpets or go out of business. Two of the

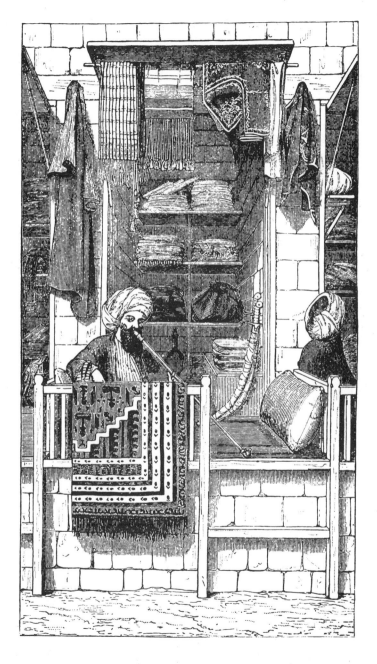

Fig. 4. Khan el Khalili carpet merchant.

three large carpet dealers, the Kahhal and Ismail Ali families, started producing hand-knotted carpets using the knowledge they had acquired through years of importing, repairing, and cleaning carpets. The third family, the Kazarounis, expanded the carpet repair and cleaning part of their business while buying and selling old Persian carpets.

Other family-owned businesses also started after the Revolution. Some were opened by weavers who were able to enlarge their businesses as demand for domestic carpets increased, while others were started by men who had repaired and cleaned carpets for the large dealers.

Today, these family-owned businesses produce carpets in their workshops, as well as provide raw materials for weavers who work on looms in private homes. This arrangement enables workshops with limited space to increase their production and allows many women to supplement the family income after marriage, since it is customary in Egypt for married women to stay at home.

In addition to the family-owned carpet businesses, there are also charitable societies founded by religious or governmental organizations whose main purpose is to teach young people a marketable skill. The majority of production sponsored by such societies takes place in workshops, not in private homes.

Another group of weavers in Egypt are Bedouin women who carry on the weaving traditions of their families. They weave rugs on primitive looms as a source of income or as part of their bridal furnishings.

TABLE 1: The Carpet Making Industry in Egypt

8

Sources for Chapter 1:

Crowfoot, Grace. "Textiles, Basketry and Mats", Chapter 16 of **A History of Technology.** Hall, A.R., Holmyard, E.J., and Singer, Charles, editors. Oxford 1954-56. Volume 1, pp. 418-19.

De Unger, E., "The Origin of the Mamluk Carpet Design". **Hali** 2 (1979): pp. 40-42.

Dimand, M.S., and Mailey, Jean. **Oriental Rugs in the Metropolitan Museum of Art,** 1973: pp. 8-11.

Forbes, R.S.. **Studies in Ancient Technology.** Second revised edition. Leiden: E.J. Brill, 1967 Volume IV: pp. 14-15.

Kuhnel, Ernest. **Cairene Rugs and Others Technically Related: 15th-17th Century.** Washington, D.C.: National Publishing Co., 1957.

Lucas, A.. **Ancient Egyptian Materials and Industries.** Second edition. London: Edward Arnold and Co., 1926: p. 168.

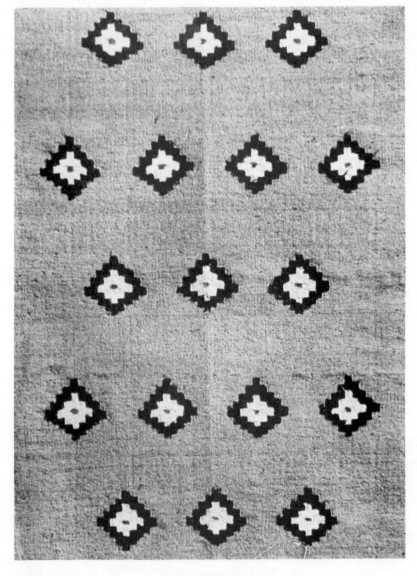

Plate 1. Assyuti kilim.

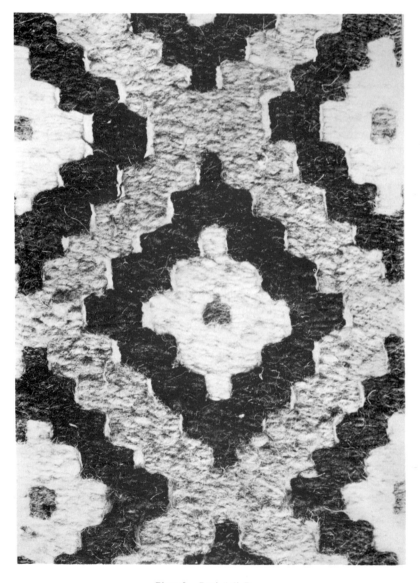

Plate 2. Beni Adi Rug.

2 The Mechanics of Carpet Making

Imagine yourself walking into a carpet shop somewhere in Cairo. As you leave the busy street and pass through the narrow doorway, you see carpets everywhere. They are hanging from the walls and stacked in piles on the floor. Vibrant colors in striking patterns compete for your attention. You don't know where to start looking first. How will you ever be able to choose one carpet from so many and how can you ever be sure you are getting a fair deal?

Asking the right questions and being able to understand the answers will simplify your task. The information in the next two chapters will help you to get started by answering many of the questions that you may already have. It will also answer questions that you may be unable to ask at certain shops if you do not speak Arabic well.

As you look at Egyptian carpets you will be deciding how much money you want to spend, which type of carpet you prefer, and where the carpet will go in your home. Chapter Two describes how Egyptian carpets are made, while Chapter Three describes what materials are used to make them. This information will help you to make your decisions wisely and may prevent you from making a costly mistake. Read both chapters quickly before you start looking at carpets and then refer to them on your carpet-buying expeditions.

How Egyptian Carpets are Made

A hand-made carpet passes through many pairs of skilled hands before it is ready for sale. Knowing how a carpet is made adds to your appreciation of the labor and skill that were needed to create the carpet you buy. It will also help you to distinguish a well made carpet from a poorly made one.

The Loom.

A carpet is woven on a loom which provides a frame for the rug while it is being woven. Different looms are used to produce the various types of carpets made in Egypt. Most of these looms are built by hand; special parts are created with available materials and considerable

ingenuity. A few carpet shops have set up looms in their showrooms so that you will be able to observe how some types of rugs are made.

Today in Egypt three types of looms are used to weave hand-made carpets: the horizontal loom, the vertical loom and the floor loom.

The Horizontal Loom. The horizontal loom, perhaps because it is so simple and yet so functional, has been used in Egypt for over five thousand years. One end of the loom consists of two stakes pounded in the ground with a rod running between them. At the other end are two more stakes holding another rod in place. The warp threads run between these two rods. The weaver sits on the ground at one end of the loom, keeping the warp threads taut, and can only weave as far and wide as her arms reach. This loom produces long narrow pieces which are sewn together to make larger floor coverings and is most frequently used by formerly nomadic people living in the desert regions of Egypt.

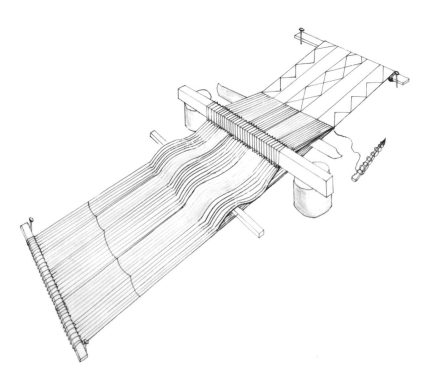

Fig. 5. Horizontal Ground Loom.

13

The Vertical Loom. The horizontal loom was used exclusively in Egypt until the vertical loom was introduced by the Hyksos who conquered and ruled Egypt during the seventeenth century B.C. The vertical loom, which was only one of many innovations brought to Egypt by these invaders from the north, was an improvement over the horizontal loom. The vertical working surface allowed the weaver to sit in a more comfortable position while working. The width of the carpet was no longer restricted by the reach of the weaver's arms since more than one weaver could work on the same loom. This type of loom is now being used to make hand-knotted carpets and tapestries. Creating detailed patterns, which are typical of these types of carpets, is easier on the vertical working surface.

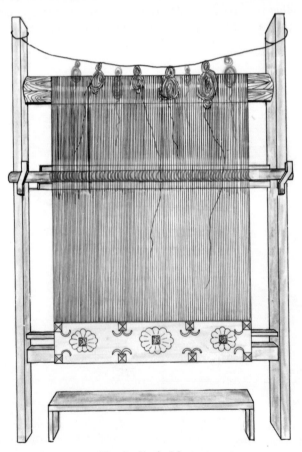

Fig. 6. Vertical Loom.

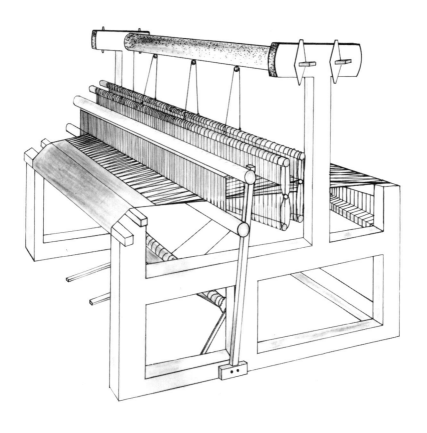

Fig. 7. Floor Loom.

Warp and Weft.

Weaving requires two kinds of threads, the warp and the weft. Warp threads run the length of the carpet and form the base upon which it is woven. You can tell what type of warp was used by looking at a carpet's fringe. Cotton, wool and silk are all used in Egypt as warp material.

The weft is a continuous thread which is woven under and over each successive warp thread across the width of the rug. Warp and weft are two important terms which will be used thoughout the book, so you will want to keep them in mind.

Fig. 8. A front view of the warp and weft.

WARP

WEFT →

WARP WEFT

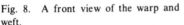

Fig. 9. A side view of the warp and weft.

One of the main functions of the loom is to facilitate the passage of the weft across the warp. The position of the warp threads must be changed after the first passage of the weft to create a mesh which will not unravel. The two parts of the loom which work together to perform this function are called the shed stick and the heddle bar.

The shed stick is placed across the width of the loom separating the even and odd numbered warp threads. The placement of the shed stick forms a space, the shed, that the weft can pass through on its first trip across the rug. The warp threads must change position for the return trip of the weft. This is where the heddle bar comes in.

In its simplest form, the heddle bar is a rod with string looped around it which is attached to each odd numbered warp. For the second pass of the weft it is lifted raising the odd numbered warp threads above the even ones to form a space called the countershed. The weft passes through the countershed and then the heddle bar is returned to its original or resting position.

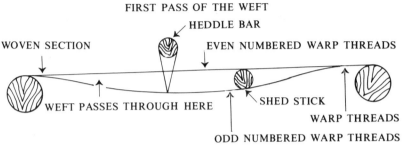

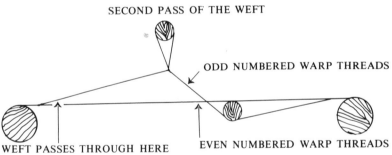

Fig. 10. Two steps in weaving: the first and second passes of the weft.

Between each pass, the weft is beaten with a comb-like instrument to press it against the previous row so that the tightness of the weave is uniform. These steps are repeated hundreds of times depending on the size of the carpet.

The basic principles of weaving are similar for all rugs, but there are variations which give each type of rug its distinctive appearance. Flat woven carpets, such as kilims, tapestries and Bedouin rugs, are made by adapting the basic weaving process described above.

Pile rugs are woven differently, with the variation in the weaving process occuring after two or three rows of weft have been woven. A line of knots is tied onto pairs of warp threads with a piece of yarn which is cut off after each knot leaving a tassel. After the rug is completed, the tassels are sheared uniformly and the individually tied knots form a pile.

3. Materials Used in Egyptian Hand-Made Carpets

Wool, silk, and cotton are used to spin the yarn used in most Egyptian hand-made carpets. Table Two illustrates the various combinations of warp, weft and pile that occur within each category of carpet.

All these fibers are natural products of plants, animals or insects. Natural fibers are expensive to produce, but they possess certain

TABLE 2: Types of Fibers Used in Egyptian Hand-Made Carpets

TYPE OF CARPET	WARP	WEFT	PILE
HAND-KNOTTED	WOOL COTTON SILK SILK	WOOL COTTON COTTON SILK	WOOL WOOL WOOL SILK
KILIMS	WOOL COTTON	WOOL WOOL	
TAPESTRIES	COTTON	WOOL	
BEDOUIN	WOOL	WOOL	
RAG RUGS	COTTON	COTTON (fabric scraps)	

characteristics which add to the attractiveness and durability of a carpet, and which are difficult for man-made fibers to imitate. The following sections describe the unique characteristics of each of these fibers and how they are prepared and used in carpet making.

WOOL

Wool is the type of fiber most frequently used in hand-made carpets. Several characteristics of this fiber make it especially well suited for carpet making. First, it can be easily spun into yarn: the surface of the wool fibers consists of small plates or scales which catch on each other when several fibers are twisted together, forming a strong yarn. Secondly, due to its natural waviness or crimp, wool can be walked on repeatedly and will spring back to its original shape. This natural crimp of wool also traps air, providing good insulation. Finally, wool has a natural resistance to moisture and is stain resistant if spills are cleaned immediately.

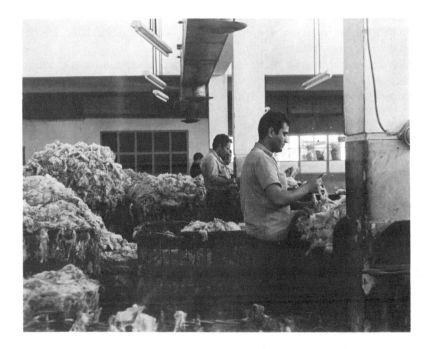

Plate 3. Sorting imported wool into fine, medium and coarse qualities.

19

Wool is similar to human hair in its physical composition and like human hair it occurs in fine, medium and coarse textures. The texture of wool depends chiefly on the breed of sheep, but climate and diet also affect its quality. Wool is classified into broad categories based on the physical characteristics of fiber length, thickness and crimp.

Fine quality wool has shorter, thinner fibers with more crimps than the other types and is used to make clothing. However, some Egyptian carpet makers use fine quality wool to make hand-knotted carpets, usually in combination with a silk warp. They refer to this type of wool as "tops". Medium quality wool is used to make blankets, tweed material, and yarn for knitting. Coarse quality wool is longer and thicker with fewer crimps than the other types of wool. It is used primarily for making carpets and some blankets. Its thicker, stronger fibers make an excellent carpet yarn which withstands constant wear.

Egyptian carpet makers use either imported wool, locally raised wool or a blend of these two types to produce hand-made carpets. The type of wool used to make a carpet affects its cost and its quality. Egyptian wool is used exclusively in kilims, tapestries, Bedouin rugs and in less expensive hand-knotted carpets. Imported wool, which is more expensive, is reserved for making the better quality hand-knotted carpets which require a thin, tightly-spun yarn to achieve a higher density of knots. To make knotted carpets more moderately priced, imported and domestic wools are blended. When you are looking at carpets be sure to ask what kind of wool was used to make them.

Imported Wool

Wool is imported from Australia, New Zealand and England in 'grease' form, that is, it has been sheared from the hides of live sheep and not yet processed. To produce a yarn which can be used in making carpets, imported wool must go through the following processes:

Sorting. Since fine, medium and coarse fibers can be found on different parts of the same fleece, the wool is examined and sorted by hand into these categories.

Scouring. After the fibers are sorted, the wool must be cleaned or scoured in a soap and soda solution since it is full of grease and dirt. Lanolin, the oil which naturally occurs in sheep wool, is removed during this stage. Therefore as a last step mineral oil is mixed with the wool so it will not become brittle and break when it is carded.

Carding. During this process the wool fibers are fed onto a machine which has rollers covered with steel wire bristles. These rollers

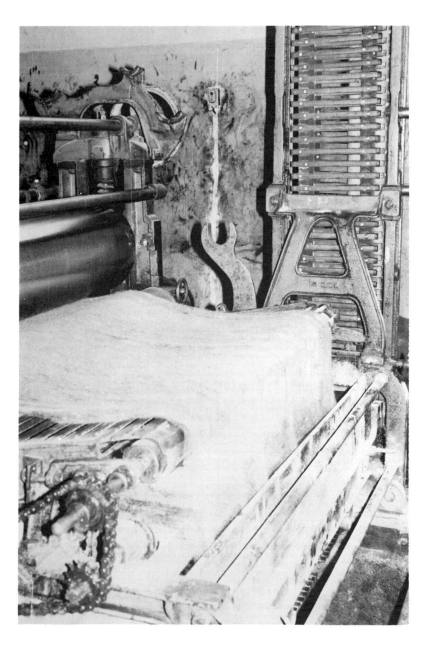

Plate 4. Carding imported wool.

move at different speeds, straightening the wool fibers into a gossamer-like sheet which is then divided and rolled onto bobbins.

Spinning. The carded wool is drawn out at a set rate and at the same time twisted to give strength to the yarn. The yarn can be spun into a variety of thicknesses, depending on the carpet maker's specifications.

Dyeing. The wool fibers can be dyed either after scouring or after the wool has been spun into yarn.

Processing of imported wool takes place in modern spinning factories which were built in the 1960s and 1970s, a period of rapid industrialization in Egypt. The availability of this modern spinning equipment has had an important impact on the hand-knotted carpet industry. Prior to this time, it was difficult to produce large quantities of the thin, tightly-spun yarn needed to make high quality hand-knotted carpets. Now the public sector spinning companies provide this higher quality yarn to most of the hand-knotted carpet makers. (There are a few private sector companies which have equipment to produce their own yarn.) The availabity of this yarn has caused a dramatic increase in the production of higher quality carpets which can compete on the world market.

Local Wool

In Egypt, sheep are raised for their meat, not their wool. The number of sheep raised is limited by the small area of land available for grazing. In the Nile valley, because every square *feddan* (roughly equivalent to an acre) is needed for the cultivation of crops, no pasture land is available. There are four major breeds of sheep: Rahmani, Barki, Ossimi and Baladi. These breeds are all characterized by a fatty tail. The Rahmani sheep are easily distinguished since they are the only breed completely brown or black. This wool is often used to make the patterns in kilims.

The other breeds are white and have dark faces. The Ossimi breed is raised mainly in the Delta region, while the Barki are raised in the desert areas by the Bedouins. Baladi, which means country or common, is a mixture of the other breeds. The Department of Agriculture has made several attempts to introduce foreign breeds of sheep that are better meat producers, but sheep herders are wary of these new breeds because they do not have the characteristic fatty tail.

Farmers raise sheep in small flocks of up to twenty, which are allowed to forage along the banks of the numerous canals or in fields that have just been harvested.

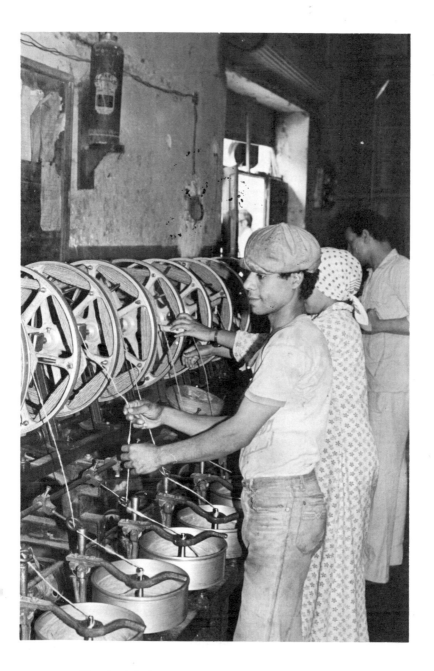

Plate 5. Spinning local wool into yarn for carpet making.

In the desert regions, where the majority of Egyptian sheep are raised by Bedouins, the flocks are larger but rarely contain more than a hundred animals.

The sheep are sheared annually in the desert areas and twice a year in the Nile valley. Until recently, the wool was not valued by the sheep herders and the shearers were allowed to take the clipped fleece free of charge or for a very small fee. Now, with the increasing demand of the Egyptian carpet industry for wool, the Bedouins and farmers are becoming more interested in its production.

After being sheared, local wool is collected from isolated villages in small lots and then sold to larger wool merchants who scour and bale it. As it is being processed, the sorting stage is left out. This means that when the wool is spun it is still a combination of short, medium, and long fibers which is difficult to spin into a thin yarn. This is why Egyptian wool is used to make those types of carpets which require a thick yarn, such as kilims. Also, because the sheep are raised in such a rugged environment, the wool can sometimes be very dirty and difficult to clean.

Some kilim carpets are made with what is known as pulled wool. This is wool which has been removed from sheep pelts during the tanning process. It is widely available here since most Egyptian sheep are slaughtered for their meat. Pulled wool is dull and brittle since the chemicals used to remove the wool from the pelt strip its natural oils, and it can be recognized by a lack of luster. Avoid buying a rug made with pulled wool even though it may be cheaper, as it will always look dull and will not wear well.

CAMEL HAIR

Sometimes camel hair is blended to lighten the colors of the brown or black wool. Camel hair does not have the crimp of wool nor does it accept dyes as readily. Saddle blankets are often made with a blend of camel hair and wool.

COTTON

Cotton is the white fluffy fiber that is attached to the seed of the cotton plant. It is flat, one-celled and varies in length from half an inch to two-and-a-half inches. Under the microscope, it looks like a ribbon that has been twisted. The more twists there are in the cotton fiber, the stronger the thread spun from it will be. This characteristic twist makes it impossible for man-made fabrics to imitate cotton exactly.

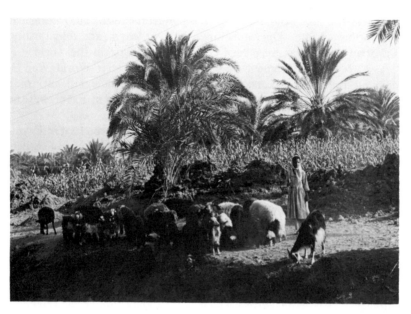

Plate 6. Herding sheep along a canal of the Nile.

Plate 7. Sheep at the butcher.

The hot, sunny climate of Egypt is perfect for cotton cultivation and cotton thrives here. Due to its long staple, or length, and silky quality, Egyptian cotton has long been considered the best in the world.

With the development of man-made fibers after World War II, demand for cotton decreased and Egypt suffered significant trade deficits. Today, cotton is still an important product of Egypt, but the days of world-wide demand are gone.

Cotton warp is used in the majority of carpets produced in Egypt, and without the firm, inflexible base that it provides, Egyptian carpets would not be as durable or as evenly woven as they are. Cotton warp will not shrink or stretch no matter how long it takes to weave a rug; this is especially important in the case of hand-knotted carpets and tapestries, which can take months to finish.

If a hand-knotted carpet has a cotton warp, the weft will also be cotton; only the pile will be wool. Since cotton is heavier than wool, the cotton weft will distribute weight throughout the carpet keeping it flat on the floor.

In Egypt, the cotton used for the warp is inexpensive. It is purchased in a standard size which is then plied to give the thickness required for the type of rug that is being woven.

Plate 8. Imported wool being dyed.

SILK

Silk is a long, continuous, protein filament which is spun as a cocoon by the silk worm, which feeds on mulberry leaves. Each cocoon is spun from one long filament of silk from eight hundred to twelve hundred yards long. The cocoons are collected and the silk fiber is unwound onto large reels. The fibers from five to twenty cocoons are usually reeled together since a single strand would be difficult to see and impractical to work with. Throughout these steps the silk fiber is still coated with sericin, a gummy substance secreted by the silk worm which strengthens the silk fiber but gives it a dull, yellowish cast. After the sericin is removed the silk fiber becomes white and translucent.

In Egypt, silk is used to make the finest and most expensive hand-knotted carpets. These include wool carpets in which silk is used as the warp and to accent the designs, and carpets made completely of silk including the warp, weft and pile.

Silk is imported from China already degummed and spun into yarn, and it is dyed in Egypt with Swiss dyes specifically designed for Oriental carpets. A trade agreement between China and Egypt keeps the price of Chinese silk artificially low. Silk is produced locally on a small scale, but is not currently being used in carpets.

Although the beauty of a silk carpet is unparalleled, it is more delicate than one made from wool. Silk carpets are usually purchased either to be hung on the wall or to be placed in an area where there will not be much foot traffic. Silk denotes elegance. When it is woven into carpets the effect is luxurious and the carpet becomes an item of pure luxury.

DYES

Unless a carpet is made in natural shades of wool or silk, its color has been created by using a dye. Until the middle of the nineteenth century, the only dyes available were natural dyes extracted from large quantities of such sources as plants, insects and flowers. The use of natural dyes was a difficult craft requiring skill and knowledge. In the carpet-making areas of Persia, Turkey and Asia Minor, recipes for certain colors were developed and passed down from generation to generation.

In 1856, the first synthetic dye was developed. Since then natural dyes have been replaced by the cheaper and easier to use synthetic dyes. Good quality synthetic dyes yield a wide range of colors and their light and water fastness is internationally standardized.

Natural dyes fade gradually over the years, and the color of the carpet becomes muted. To imitate these muted colors in modern Oriental carpets, a chemical wash was developed which mellows the colors of the carpet without greatly affecting its durability or strength.

The Process of Dyeing

Fibers react differently to dyes. Wool is a protein fiber and accepts dyes easily, but the intensity of the resulting color depends on the quality of the wool. Fine quality wool absorbs more color than coarser qualities since there is more surface area for the dye to adhere to. Silk, which is also a protein fiber, accepts dyes easily and the colors are brilliant.

A dye must be water and light fast so that the colors will not run together when washed or fade when exposed to sunlight. Many carpets in Egypt are woven in natural colors of wool. Brown and black wool are mixed with the normal cream-colored wool or with camel hair to create a variety of hues including beige, light brown, dark brown and grey. The better quality kilims are woven exclusively from natural-colored wool, so you do not have to worry about the colors running together or fading. If you buy an Oriental carpet from a reputable Egyptian dealer, you can also be sure that there will be no problems, as all of them use only high standard European dyes in their carpets.

In Bedouin carpets, however, the colors probably will run since the yarn is dyed under primitive conditions with dyes which are not colorfast. Before you buy one, check the entire carpet to make sure that the colors have not bled already. Another type of carpet in which the colors may not be colorfast is the Assyuti kilim, in which local dyes are used.

If you would like to check the colorfastness of a carpet, rub a damp white cotton cloth over its surface. If no color comes off, then the rug is colorfast.

4 Flat Woven Carpets

You can see Egyptian flat woven rugs without even entering a carpet store: you will find them hanging out of windows or over balconies on cleaning day and decorating many restaurants and shops. Flat woven rugs have no pile and are woven like cloth with a wide variety of fibers. Nomads are credited with their development, and flat woven rugs were particularly suited to the nomadic way of life. They were portable, easy to weave and could perform double functions—a saddle bag could become a cushion, and a blanket a floor covering or tent divider.

Designs that originally were simple became more elaborate as the weavers became more skilled, especially in countries such as Turkey and Persia. In Egypt, the designs are still simple and rarely cover the entire field of the carpet.

Before mechanization of the loom, flat woven rugs, produced quickly and cheaply, were the most common type of carpet. Only the wealthy could afford to buy hand-knotted pile carpets. Now modern machines produce pile carpets in a matter of minutes, and hand-made flat woven rugs have become the exception rather than the rule. Because they are woven by hand each rug is unique, but they are not expensive. If you want an affordable and attractive hand-made carpet, be sure to look at the wide selection of flat woven rugs available in Egypt.

Egyptian flat woven rugs can be classified into the following five groups based on how they are woven and what they are made of:

Tapestries (called "Gobelins") are woven scenes which are usually hung on the wall.

Kilims are wool rugs woven in a variety of styles, notably Assyuti or Helwan, and are the most prevalent type of Egyptian rug.

Bedouin rugs ("kilim Badawi") are woven in brightly colored wool on horizontal ground looms.

Beni Adi rugs ("sigad Beni Adi") are woven in natural colors of wool with complex geometrical designs.

Rag rugs ("kilim umash") are woven from scraps of fabric and can be used in a variety of ways, for example, as bath mats or beach mats.

TABLE 3: The Different Types of Flat Woven Rugs

Type	Warp	Weft	Colors	Designs
Tapestry	Cotton	Wool	Primary	Egyptian rural scenes
Assyuti Kilims	Cotton	Wool	Natural Primary	Solid Plaid Nomadic designs
Helwan Kilims	Wool	Wool	Natural	Linear geometrical Arabic designs
Turkish Persian Kilims	Cotton	Wool	Primary	Turkish and Persian designs
Bedouin Rugs	Wool	Wool	Primary	Stripes
Beni Adi Rugs	Wool	Wool	Natural	Geometrical, covering the entire surface of the rug
Rag Rugs	Cotton	Fabric scraps usually cotton	Multi-colored	Stripes solid checkerboard

Types of Weaves

The unique appearance of each type of rug is a product of the materials used and the way it is woven. Egyptian flat woven rugs are woven in four ways: weft face, warp face, tapestry, and, the least common, Soumak weave. A description of each type follows.

Weft Face Weave. In this type of weave, the weft yarn is thicker than the warp. When the rows of weft are compressed against each other they completely cover the warp and form the surface of the rug. Kilims and rag rugs are woven in this style.

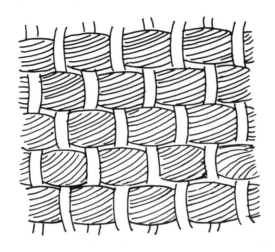

Fig. 11. Weft face weave.

Tapestry Weave. A type of weft face weave, this technique is used to form complicated designs. Different colors of weft are woven back and forth in specific areas according to the design, and the weft is rarely carried completely across the warp in one shot. If an interlocking stitch is used, there will be no slit where the colors have been changed. This style of weaving is popular in Egypt and is used to produce tapestries.

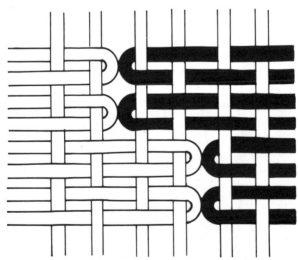

Fig. 12. Non-interlocking tapestry weave. A slit appears where the colors have been changed.

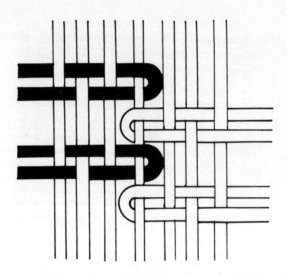

Fig. 13. Interlocking tapestry weave. No slit appears where the colors have been changed.

Warp Face Weave. This is the opposite of the weft face weave: the warp completely covers the weft and forms the surface of the rug. Bedouin rugs are woven in this way.

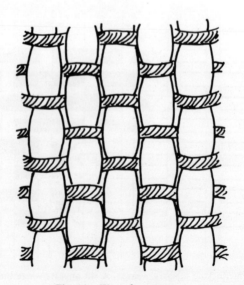

Fig. 14. Warp face weave.

Soumak Weave. This type of weave, a form of weft wrapping, is rare in Egypt. In the front of the carpet the weft is carried over an even number of warp threads. Then it is wrapped from behind, coming out in the middle of the warp it has just passed over. This process is continued across the width of the carpet. The surface of the rug is smooth, and there are usually ends of yarn hanging from the back. Some Bedouin rugs are woven in this style.

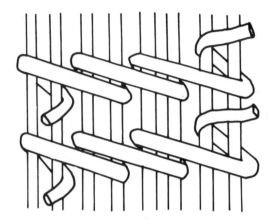

Fig. 15. Soumak weave.

Tapestries

Tapestries are the brightly woven scenes of Egypt which are displayed in souvenir shops along with alabaster pyramids, papyrus and galabeyas.

Tapestry weaving was an art in Coptic Egypt which disappeared in the twelfth century A.D.. The man responsible for its recent rebirth in Egypt is the late Ramses Wissa Wassef who, in 1952, started an art school for *fellaheen* children in the countryside outside of Cairo. He started the school as an experiment to develop creative abilities in children untouched by the age of technology. Children, chosen randomly from the surrounding countryside, were taught how to weave. A surprising number enjoyed it and wove scenes from their daily life such as weddings and market days which were charming in their simplicity. For an example of a tapestry made at his art school in Haraneya, see plate 25.

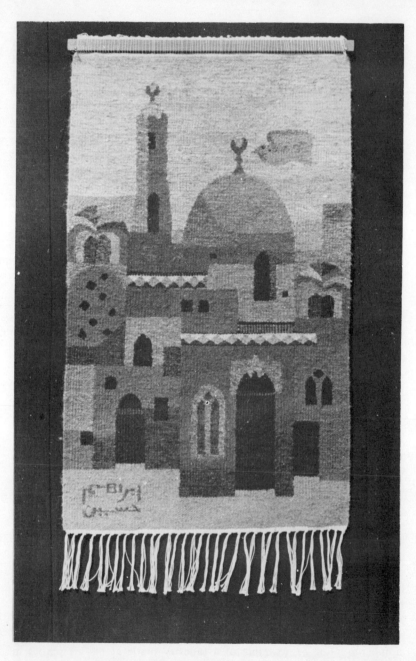

Plate 9. A tapestry designed by Ibrahim Hussein.

34

The tapestries were exhibited in Egypt and abroad, and the reputation of the Art School spread. It is now operated by the family of Ramses Wissa Wassef and is open to the public. The school has inspired many people, some of whom have started similar schools such as the Atelier des Pyramides. Meanwhile, other artists such as Ibrahim Hussein began weaving (see Chapter Seven).

Fig. 16. The design of one of the tapestries produced at the Masged el Hadeya in Alexandria. It is the ceiling design in the mosque where the carpets are produced.

Since the tapestries appealed to foreigners, businessmen started producing them in large numbers for the tourist market. They are attractive and good souvenirs of Egypt but their price has increased along with the demand for them.

Tapestries are woven on vertical looms similar to the ones used for hand-knotted carpets. The weaver sits in front and usually works from side to side, weaving images with no picture to guide him.

In the art schools, children should ideally start weaving at the age of ten and continue to weave as they mature. But the girls often stop weaving after they get married and the boys after they are drafted into the Army. The Ramses Wissa Wassef Art School is the only school which has managed to keep their weavers for long periods of time. Some of them have been working there for twenty and thirty years, while in other schools the average is five years.

Weaving is not easy and children must be patient to learn. First, they learn the basics of weaving and then through practice they learn how to transfer the image in their mind onto the tapestry. After they choose the color they want, they weave it in and out of the warp by hand. They use a hand-held beater to compact the colors; soon a picture appears which they add to daily until the tapestry is finished.

Fig. 17. Hand-held beater used in weaving tapestries.

Tapestries are woven in this way in schools where creativity is encouraged. When they are woven for tourists, they are usually mass produced by weavers who are paid by the meter. The designs are copied and generally easy to weave.

Kilims

In this book, kilim refers to wool flat woven rugs made on a floor loom. The two most common type of kilims produced in Egypt are the Assyuti kilims, which are produced for the local market, and the Helwan

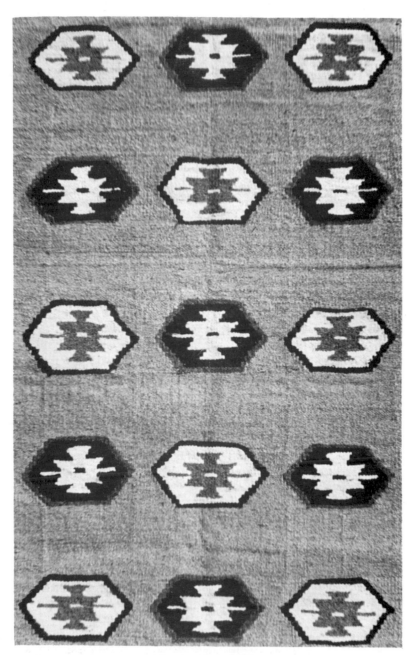

Plate 10. Assyuti kilim.

kilims, which are produced for the foreign market. Copies of Persian and Turkish kilims are also becoming more common.

Assyuti kilims are named after the city of Assyut in Upper Egypt where they must have been woven originally. They are interesting carpets in that they reflect the Egyptian love of bright colors and their designs are part of a weaving tradition developed in Egypt.

Assyuti kilims have a cotton warp and are noticeably thinner than Helwan kilims. They are less expensive than machine-made carpets and can be found in most Egyptian homes.

Because these carpets are produced for the local market, their price must remain low. To compensate for the rising cost of wool, many manufacturers have discovered ways to decrease their production costs. The most common method is to weave kilims with yarn spun from pulled wool, which is bought from slaughter houses at half the price of shorn wool (see the section on wool in Chapter Three).

Some enterprising manufacturers have discovered another source of inexpensive wool. They buy wool fabric and jersey scraps from clothing factories for as little as twenty-five piasters a kilogram and feed them to a machine which unravels them. The recovered wool fibers are mixed with pulled wool and respun into yarn. Another money-saver is fibrous cigarette filter material, which is bought in bulk from cigarette factories where it is a waste product. It is added to wool as a filler and then spun into yarn. A rug woven with wool and cigarette filters feels scratchier than one woven with pure wool. Not all Assyuti kilims are woven with impure yarn, but you should be careful when buying one.

Assyuti kilims are sometimes woven in natural colors, but more often in primary colors with black and white accents. The most common design is a plaid with two colors, one of which is usually black. Most of the designs were adapted from Beni Adi rugs and other nomadic kilims.

Figures 18, 19, 20 and 21 (following two pages). Various designs which appear in Assyuti Kilims.

Helwan kilims were developed to appeal to Western tastes and are exported to Europe or sold to tourists and foreign residents of Egypt. They were first woven in Helwan and are referred to as Helwan, Super Helwan, or Double kilims. The wool warp and thickness of the carpet immediately distinguish Helwan kilims from the other types of kilims.

Many Egyptian rug merchants have developed their businesses around this type of kilim. They are proud of their rugs and carefully control each step of the production. Local shorn wool is used, and one hundred percent wool rugs are woven under supervision in their workshops. After the rugs are finished, they are washed and often mothproofed before they are sold in their stores or exported.

But there are imitators who weave rugs similar to the Helwan kilims with adulterated or dirty wool. If you are buying rugs from a reputable merchant you do not have to worry. But if you are buying a carpet anywhere else, check it carefully. If it feels greasy or looks dirty you can assume that care was not taken in its production, and it may not be made of pure wool.

Helwan kilims are woven in natural colors. The first ones were woven in linear and geometrical designs developed in Switzerland and still used today.

Figures 22, 23, and 24. Three Swiss Helwan kilim designs.

41

Some weavers have simplified and adapted what they call Arabic designs to the Helwan kilims.

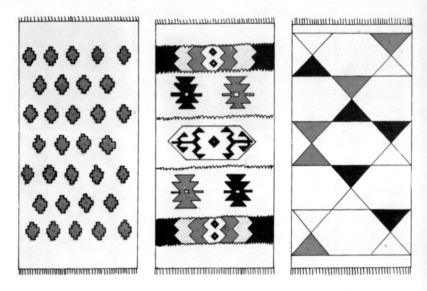

Figures 25, 26, and 27. Three Arab designs used in Helwan kilims.

Turkish and Persian Kilims Imitations of Persian and Turkish kilims have begun to appear in some rug shops. These rugs are similar to Assyuti kilims in their use of a cotton warp and a thin weft, but the standard of their workmanship is higher. They have borders and the designs are usually much more complicated than those of the Assyuti kilims. The most common color combination is red, black and white.

Weaving Kilims

Kilims are woven on heavy floor looms called treadle looms. These looms are not made in a factory but are commissioned from carpenters by carpet manufacturers or weavers. They are roughly hewn but sturdy and resemble each other in the important details. Foot pedals operate two heddle bars which are attached to each other by a pulley system so that when one heddle bar goes up, the other one goes down, changing the shed. A shuttle which looks like a flat boat is used to carry the weft

Figures 28 and 29. Two Nomadic designs which appear frequently in Egyptian kilims which imitate Turkish and Persian kilims.

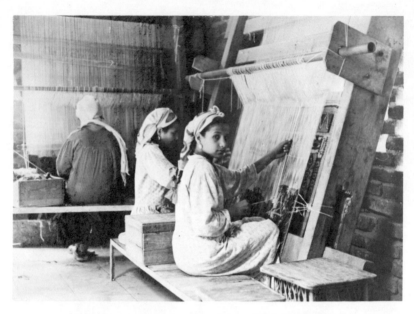

Plate 11. Tapestry weavers at the Atelier des Pyramides.

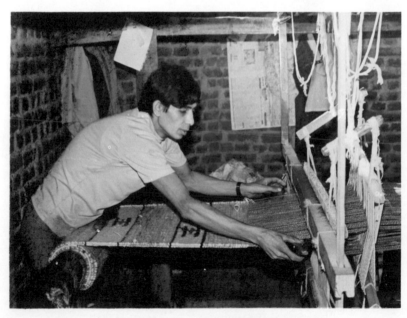

Plate 12. Kilim weaver.

44

across the warp and a reed beater is used to compress each row of weft against the others.

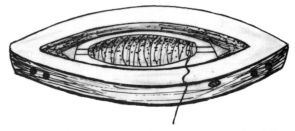

Fig. 30. The shuttle which carries the weft across the loom when kilims are woven.

To weave designs, an interlocking stitch is used so that there will be no slit where the colors have been changed. If there is a slit, the rug is probably from Beni Adi or an Assyuti kilim. The foot pedals make this type of loom efficient, and a meter can be woven in an hour. Only men weave kilims since, according to Egyptian carpet makers, the work is physically demanding.

Bedouin Rugs

Egyptians call Bedouins "Arabs" in reference to their probable origin in the Arabian peninsula. Until this century their main livelihood was the caravan trade. Now, since there are no more caravans, they have grudgingly changed their way of life and settled on the edge of desert areas. Some make a living herding sheep and goats while others cultivate crops. Bedouins live in insular tribal groups in three areas in Egypt: The Western Desert, the area west of the Nile Valley to the Libyan border; The Eastern Desert, the area east of the Nile Valley to the Red Sea; and the Sinai peninsula.

Not all Egyptian Bedouins weave rugs, and those that do are usually sheep herders who weave their wool into brightly colored flat woven rugs on horizontal ground looms. One of the main regions in which these rugs are woven is along the Mediterannean coast west of Alexandria. Bedouin families have settled here and live in isolated stone houses. One or two women in many of these families weave carpets which are sold throughout Egypt but mainly in Hammam (see Chapter 7). The women dress distinctively in bright colors with sashes tied around their hips.

Their love of color is reflected in the rugs they weave, and bright red is often the prominent color. The rugs are woven in long narrow strips and then sewn together to make larger pieces. Since these pieces are never exactly the same length, one end of the rug will be uneven.

Bedouin women weave rugs on the oldest existing type of loom. It is staked out on the ground by four iron pegs, with two iron bars running across each end. The only other parts of the loom are a heddle bar, two cans or rocks to hold the heddle bar up, and a shed stick. Weaving is usually done in a hut; the loom starts inside the hut and stretches out of the door into the yard. The weaver sits inside the hut and as the weaving progresses rolls up the woven section and sits on it (see plate 27).

The yarn used for the rugs is spun by Bedouin women from wool which is either purchased or shorn from their own sheep. The wool is spun into yarn by hand, a time-consuming task. The spindle is rudimentary and consists of a stick with a nail on the top to guide the yarn and a piece of rubber to keep the growing ball of yarn from spinning off the top. Although it looks easy, spinning yarn takes a lot of coordination since the hands perform separate tasks. One hand pulls the wool fibers out and twists them, while the other one quickly spins the spindle, where the yarn is collected.

After the yarn is spun, it is dyed with local dyes, and then the yarn is plyed. To do this, two strands of yarn, which are rolled together into a ball, are attached to a spindle. One hand grasps the yarn, holding it tautly, while the other hand rolls the spindle against the outside of the thigh above the knee. As the yarn is plyed, it is wrapped onto the spindle. Many Bedouin women have an indentation in their thighs from many years of rolling the spindle in the same place.

To weave, the women sit on the ground in a position which looks comfortable until you try it. One foot is folded under the body, while the other foot is flat on the ground.

Unlike any other rug woven in Egypt, the warp forms the surface of the rug in what is called a warp face weave. Different colors of yarn are warped in groups which will form stripes in the finished carpet.

Two instruments are used by the weavers. One, the swordstick, is a flat piece of wood in the shape of the blade of a sword. It is used both to separate the warp while the shed is being changed and to compress the weft strands against each other. The other instrument is the horn of a gazelle, which is used to straighten out the warp before the weft is passed through.

The designs of these carpets are not written down but have been passed down from one weaver to the next. The rugs are attractively woven in a variety of colors, most frequently red and purple stripes with beige, black, gold and green designs (see plate 26). The contrasting stripes, woven by warping the different colors of warp threads according

to the design, are the major pattern of the Bedouin rugs. All of these rugs have further designs within the striped area which are woven by bringing one of two colors of warp threads up and leaving the other on the back of the carpet.

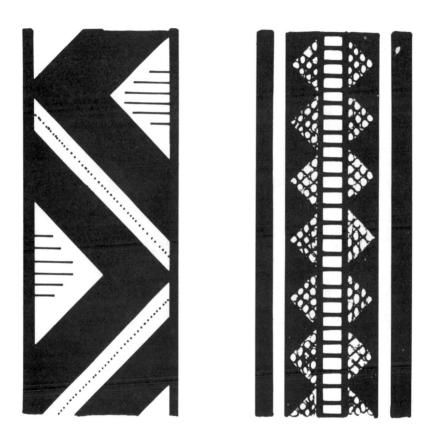

Figures 31 and 32. Designs appearing in Bedouin rugs.

Other designs within the striped area are woven with a simple but effective technique called the warp float. This technique is used to weave diamond and triangle shapes. If you turn the carpet over you will notice loops of yarn which float at the back until they are pulled up to form the pattern. When the warp float technique is used the extra ends of the warp are left dangling about six inches from the end of the carpet.

47

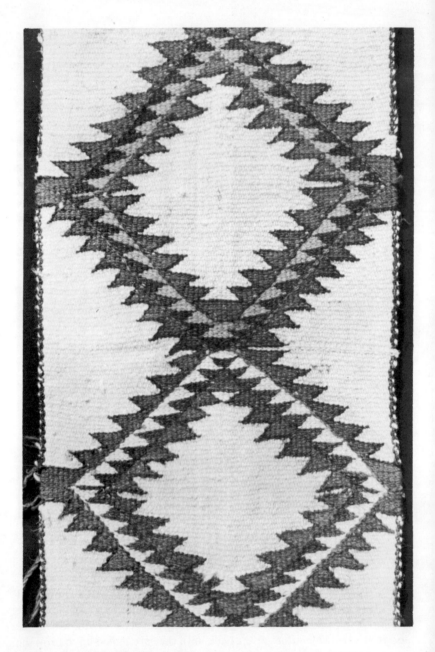

Plate 13. Bedouin carpet in Soumak weave.

Soumak Rugs

Rugs woven in the Soumak weave are immediately recognizable. They are not striped but are generally woven in a cream background with red geometrical designs. The cream area is woven in a plain weave and the designed area is woven in the Soumak weave. A sign of this type of rug is the many ends of yarn left dangling in the back. These rugs are woven in narrow strips, but are often sewn together to make a room size carpet. Either as individual strips or as large rugs they make attractive and unusual wall hangings.

Beni Adi Rugs

Beni Adi rugs are woven by women living in or around Beni Adi, a village on the edge of the Western Desert near Assyut. Weaving is part of the household duties of these women and an area is set aside in each family unit for it. The rugs are woven in natural colors—predominantly dark brown and cream. The wool is shorn from their sheep and spun into yarn by hand. Sometimes the wool is not washed before spinning and so it looks dull and feels greasy. The rugs are woven with a tapestry weave on horizontal ground looms by one or two women. No interlocking stitch is used so there is a slit where the colors have been changed.

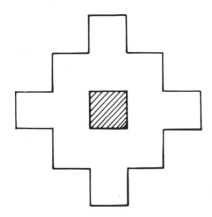

Fig. 33. A Beni Adi carpet design.

Each rug is unique, but they all have designs based on interlocking geometrical shapes. The most common designs are a stepped cross and a stepped diamond. The nearby Assyuti Technical School has isolated and simplified some of the Beni Adi designs and they often appear in Assyuti kilims.

Beni Adi rugs are sold by weight, according to the amount of wool used to make them, and can be found in some shops that specialize in kilims (see Chapter 7). If you are in Cairo, the shops that sell rag rugs near Bab Zuweila usually carry a selection of Beni Adi rugs.

Rag Rugs

Rag rugs, which are both attractive and inexpensive, originated as a way to recycle scrap fabric. Woven in bright colors, rag rugs are versatile and make good beach mats, bath mats, exercise mats, kitchen rugs and hallway runners. They are also practical since they are machine washable.

Rag rugs were originally used in Egypt as bench covers and so the most common size is .7 by 2 meters, the size of the benches. Now a double size of 1.4 by 2 meters is woven for the floor.

Rag rugs are usually woven with cotton scraps, but you can also find them woven in silk, wool and velvet. The majority of rag rug weavers work in their homes or in the workshops for large rug merchants who buy fabric cuttings in large quantities at the public auctions of clothing manufacturers. Women cut the fabric scraps into one inch wide strips, sew them end to end, and roll them into balls. These balls of weft are given to the weavers who weave the rug according to the merchant's specifications. Since the weft is thick it only takes three to four hours to weave a rag rug. After the rug is finished it is cut off the loom, the fringes are knotted and any bumps on the surface are cut off with a pair of scissors.

A smaller proportion of rag rugs are woven by small family businesses who buy their rags from the neighborhood tailor. The entire family helps weave the rugs which are then sold in their small shops.

Rag rugs brighten up any room and you will be surprised at how versatile and useful they can be.

Plate 14. Finishing a rag rug.

Plate 15. Rag rug sellers at the Esna Lock.

5 Hand-Knotted Carpets

There is an intangible mystique that surrounds the world of hand-knotted carpets. For Westerners, they often conjure up romantic visions of far away lands, filled with mystery and excitement. For Middle Easterners, they are a part of their Islamic inheritance and a link to their nomadic past. Some people find this mystique enchanting, and it is what first attracts them to hand-knotted carpets. Others may feel that this mysterious aura is too difficult to penetrate and they hesitate to venture in. But anyone can learn to appreciate this kind of carpet.

Much of the interest surrounding hand-knotted carpets is generated by antique and semi-antique rugs. During various periods over the last several hundred years, these carpets were produced by nomadic tribes for their own use, by commercial workshops for sale and by royal carpet makers for the use of the reigning monarch. For many years these older carpets have inspired the interest of scholars, who have written widely on the significance and origin of their designs.

Modern hand-knotted carpets are produced in such countries as India, Pakistan, China, Romania and Egypt, generally for export to the European and American market. It is the modern commercially produced hand-knotted carpets that will be discussed in this chapter. Older carpets of foreign origin are available in Egypt, but it is illegal to export them.

Currently, Egypt produces only a very small portion of the knotted carpets on the world market (only .04% in 1982). The majority of carpets are produced in workshops of family-owned businesses and government-operated or charitable organizations.

Workers are trained from the age of ten and according to most manufacturers it takes about five years for them to become proficient enough to work on the more complex designs. Some carpet producers think that women make better knotters because of their smaller hands, while others prefer men. In keeping with the country's social customs, men and women weavers always work separately.

Egyptian carpet makers take great pride in the production of their carpets and pay close attention to controlling the quality. This results in very high standards for the industry. In the past, however, Egyptian carpet makers have not been in close enough touch with trends in the export market and the designs and colors of their carpets have not appealed to Western tastes. This is changing as more and more carpet manufacturers become interested in exporting.

Egyptian carpet makers have further been criticized because their finishing techniques do not usually include a chemical wash to subdue the colors of the carpet. While a few carpet makers now do this, it is important to remember that not all buyers will find the effect of chemical washes attractive.

If you are interested in buying a knotted carpet while you are in Egypt, look at severall and see if their colors, designs and overal appearance appeal to you.

The hand-knotted carpet industry is currently maintaining a steady level of production. The availability of raw materials seems to be adequate to meet the demands of carpet makers. However, some carpet manufacturers are reporting difficulties in finding new workers to train. Young people seem to prefer higher paying, less tedious jobs. Because of Egypt's large population, it is difficult to predict whether or not this will have any long range effects on the country's ability to maintain its current level of production.

Until recently, the international reputation of Egyptian carpets has been slow to spread since they have not been widely exported. However, several sources claim that for many years wool and silk carpets were purchased in Egypt and resold in other countries as carpets of Persian origin. Although it is difficult to prove this definitely, it is an indication of the standards that the Egyptian carpet making industry has attained.

Because Egyptian carpets are not as well known as Persian carpets, even though they are of comparable quality, many people are reluctant to buy a carpet made in Egypt. Also, many visitors hesitate to purchase one because the prices seem high to them, and they assume that they can purchase a carpet at home for less money. If possible, look at carpets in your own country before travelling to Egypt. This will help you decide if you prefer Egyptian carpets to carpets more easily available in your home town.

Defining Quality

The term *quality* is often used when referring to carpets, but it can have many meanings. In Egypt, the quality of a hand-knotted carpet is

determined by the type of wool which is used and the number of knots per square centimeter. Egypt is one of the few countries that places such an emphasis on these two factors. In other countries, elements such as color, design, and the overall appearance of the carpet are of equal importance.

TABLE 4: The Qualities of Egyptian Carpets

Knots Per Square Centimeter	Type of Fiber Used
9 Knots (3 x 3)	Egyptian Wool
16 Knots (4 x 4)	Egyptian Wool
36 Knots (6 x 6)	Egyptian Wool Imported Wool Blend
49 Knots (7 x 7)	Egyptian Wool Imported Wool Blend
64 Knots (8 x 8)	Imported Wool (cotton warp) Imported Wool (silk warp)
81 Knots (9 x 9)	Imported Wool (silk warp) Silk
100 Knots (10 x 10)	Silk

The number of knots per square centimeter will vary with the design and the type of wool being used. The lower knotting densities, which are made with local wool, are used with simple designs. The higher knotting densities, which are made with imported wool, are used to create carpets with more intricately detailed designs. Since it takes more time to produce carpets with a large number of knots per centimeter, these carpets are more expensive.

You will rarely see carpets with only nine or sixteen knots per square centimeter since these are produced for sale on the local market where they used to be popular. Now many Egyptians are buying the attractive machine-made carpets instead of these low quality knotted ones.

TABLE 5: Chart Converting Knots per Square Centimeter into Knots per Square Inch

Number of Knots per Centimeter	Number of Knots per Inch
25	161
36	232
64	413
81	523
100	645
121	781
144	929

Silk in Egyptian Carpets

Silk is used in three different ways in Egyptian carpets. In wool carpets with more than sixty-four knots per square centimeter, silk can be used as a warp thread. Using such fine warp thread enables the weavers to tie knots more closely together and produce more detailed designs. White or undyed silk is also used to illuminate parts of the designs in higher quality carpets.

Carpets made entirely from Chinese silk are among the most famous produced in Egypt. Knotted in predominantly Persian designs, they are of outstanding quality. Some one hundred percent silk carpets have details brocaded in gold thread.

Silk carpets are commonly sold in sizes smaller than a meter and make exquisite wall decorations. When hanging your carpet, be sure to do it carefully so that its shape will not be distorted.

Although it is unlikely that a carpet made from synthetic silk would be represented as a carpet made from real silk, there is a test the shop owner can perform if you have any doubts. Ask him to take a short thread from the fringe of the carpet and burn it. Real silk fibers will not disintegrate like artificial ones, but will curl into a shiny knot.

Sources for Carpet Designs

The majority of knotted carpets made in Egypt are copied from traditional Persian, Turkish and Caucasian designs. These are taken with remarkable skill and accuracy from carpet catalogues and books. Since many carpet shops also clean carpets, sometimes a pattern of a rare old carpet will be copied when it is brought in to be cleaned.

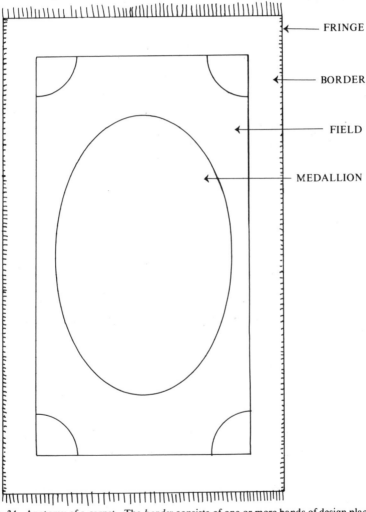

Fig. 34. Anatomy of a carpet. The *border* consists of one or more bands of design placed around the edge of the carpet. The *field* is the central rectangle of the carpet as defined by the border. The *medallion* is the design in the center of the carpet; similar patterns may appear in the corners of the field.

Names of Carpet Designs Produced in Egypt

When looking at Egyptian hand-knotted carpets, concentrate on finding a design that you think is attractive.

The names in the chart below refer to major weaving centers that were famous for producing certain types of carpets. Since each center produced many designs, you will find that two carpets called by the same name will not necessarily look alike.

TABLE 6: The Names of Different Designs

Persian	Turkish	Caucasian
Isphahan	Hereke	Kazak
Kashan	Ghiordes	Shirvan
Kerman		
Tabriz		
Nain		

Depending upon the shop you visit, you may find that carpet designs are referred to by the following names, the first five of which are of Persian origin.

Persian Garden: The field is divided into several small rectangles which each contain a stylized tree, plant or flower.

Hunt Carpet: The field depicts armed men on horseback placed randomly around the field.

Tree of Life: There are several versions of this design. All of them have a tree as the central feature of the field.

Bird Carpet: There are also several versions of this design, all of which include different types of birds perched in a tree.

Vase Design: The central medallion is actually a vase from which several curvilinear lines representing stems twine around the field of the carpet, sprouting a variety of flowers and leaves.

These designs are produced in the higher quality carpets from both wool and silk.

Persian designs use representations of human and animal figures, while Turkish designs generally use floral and geometric motifs. Caucasian designs use both, but always in stylized geometric forms.

Prayer carpets based on Persian, Turkish and Caucasian designs are found in many Egyptian carpet shops. They are easily identifiable by the arch or *mihrab* which forms the major design. This is a representation of the prayer niche found in the Great Mosque at Mecca and is always turned to face the direction of that city when used for praying.

Fig. 35. Schematic drawing of a prayer rug showing the *mihrab*.

Ninety-nine Names of God. This carpet design consists of the ninety-nine names of God which are written in Arabic script, usually in gold on a green field. This carpet can only be sold to Muslims who must promise to never place it on the floor.

THE MAKING OF A HAND-KNOTTED CARPET

There are many time-consuming steps that go into making a hand-knotted carpet. The process used in Egypt is similar to that used in other carpet producing countries.

Preparing the Loom for Weaving

Hand-knotted carpets are woven on vertical looms which have not changed significantly in design since ancient Egyptian times. First, the warp must be strung on these looms, making sure that the tension is consistently tight. The thickness and the spacing of the warp threads will play a part in determining how densely the knots can be tied.

Wool warp is usually used for the lower knotting densities. It appears most commonly in carpets with Caucasian designs which are usually executed in 25 knots per square centimeter. Cotton warp is used most frequently in carpets with 36 and 49 knots per square centimeter. Silk warp is used when a very high concentration of knots is desired (64 or more knots per square centimeter).

After the loom is warped, the shed stick is inserted to separate the even from the odd warp threads. Then either the odd or even threads are attached to the heddle bar by loops of string. Once this is completed, the weaving process can begin. During weaving, the heddle bar remains stationary and the shed stick is either raised or lowered to change the position of the warp threads. Before starting the first row of knots, a few rows of plain weave are often done with the weft thread. This gives the finished rug an attractive kilim border before the fringe.

Types of Knots

Two types of knots are used in Egyptian carpets: the Turkish knot and the Persian knot. These two types of knots are used in the majority of countries which make knotted carpets.

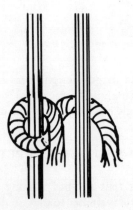

Fig. 36. Persian knot.

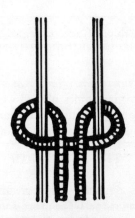

Fig. 37. Turkish knot.

The Turkish knot places two pile threads between every other pair of warp threads, while the Persian knot positions one pile thread between every warp thread, forming a more evenly distributed pile. This means that using the Persian knot will result in a finished carpet with a finer texture than one tied with the Turkish knot. Also, the Persian knot is more effective in creating patterns with greater detail and is often used for making carpets with higher knotting densities

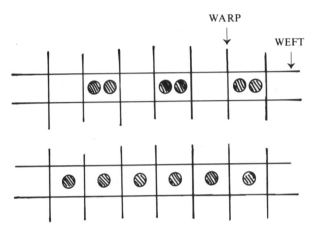

Fig. 38. Placement of the pile threads in Turkish and Persian knots viewed from above.

Knotting

The yarn for tying knots, which has already been spun, dyed and plyed, is wound onto large bobbins which are placed on top of the loom, making it easy for the weaver to reach up and choose the next color. Experienced weavers can tie over eight thousand knots per day and their fingers move so quickly that it is difficult to see the knot actually being tied. After a knot is tied, the weaver cuts the yarn, leaving long tassels which will later be trimmed.

When a row of knots has been completed, the weft, which is usually of the same material as the warp, is woven in an over-under pattern across the rug. This row is beaten with a heavy, comb-like instrument to compact it against the previous row of knots. Two or three rows of simple weaving are done like this, before another row of knots is tied. This strengthens the carpet and helps it to lie flat when finished. After every row, the shed stick is either raised or lowered to change the positions of alternate warp threads.

Weaving starts from the bottom of the loom and as it progresses, the completed portion of the carpet is moved around the lower beam of the loom to the back. This means that the weavers can always keep the area of the carpet that they are working on at a comfortable height.

As the carpet progresses, the pile formed by the previous row of knots is pushed down, so that the weaver can see what she is doing. Consequently, the pile of the carpet leans towards the end of the carpet where weaving began. Because of the direction of the pile, less light will be reflected when you stand at the end of the carpet where weaving began, making it look darker. If you stand at the end where weaving finished, the pile will look lighter. This effect is more noticeable in some carpets than in others.

The weavers frequently check the pattern board to see what color comes next in the design. Pattern boards hold the designs which have been drawn on graph paper, where every square represents a knot and the color of the square corresponds to the color of the yarn to be used.

Finishing the Carpet
Selvedges are created by wrapping the weft thread around the outer two warp cords on both sides of the rug. When the carpet is finished, these edges are overcast with wool to reinforce them. Sometimes two small matching carpets are knotted side by side on a loom. When they are cut apart, selvedges on the sides where they were joined must be created. If you are buying these types of carpets be sure to check that this was carefully done.

Trimming. The finished part of the carpet is trimmed, periodically, with a pair of scissors, designed with the handle bent up from the blade. This allows the weaver to trim the pile closely without interference from her hand. Also, the denser the knotting, the more closely the pile can be trimmed.

Scorching. Some manufacturers singe the back of each carpet with a blow torch to remove any loose pieces of yarn.

Fringes. After a carpet is finished and removed from the loom, the warp ends must be secured in some way so that the carpet does not unravel. In Egypt, they are usually gathered in bunches and tied into an overhand knot. Be sure that any carpet you buy has the warp ends finished in some manner.

Washing. Since most hand-knotted carpets are on the loom for months, once they are finished they must be washed to remove all the

dirt and dust that has accumulated. This is done with soap and water. After they are washed, the carpets are trimmed again.

Oriental Washes. A few workshops in Egypt treat their carpets with what is called an Oriental wash. This is a chemical solution which softens and darkens the colors. It was invented to give the colors created by chemical dyes the same subdued quality as those created by natural dyes. The type of mild solution used in Egypt does not damage the wool fiber. Try to compare carpets which have been washed with those which have not and decide for yourself which effect you find more pleasing.

How to Tell a Machine-Made Carpet From a Hand-Made One

Machine-made rugs are usually referred to as "Oriental design carpets". Be sure that you can distinguish carpets made by machine from ones that are made by hand. This is not as difficult as it sounds, but it does take a little practice; a look at plate 18 should help.

Four important areas to check are the fringe, the selvedges, the back and the pile.

Fringe: Since the back of a machine-made carpet is formed by a heavy fiber material instead of warp threads, the fringe is not an extension of the warp and must be sewn on.

Selvedges: In machine-made carpets, selvedges are sewn on instead of being wrapped as in knotted carpets. The difference between the two becomes more apparent if you look at the selvedges from the back of the carpet. The selvedges of a machine-made carpet lie flatter than those of a knotted one, which may curl under slightly.

Back: On the back of a hand-knotted carpet, you can easily distinguish the design which forms the pile. Also, there will be some irregularities. With a machine-made carpet, the design is not as distinct and has a pale or washed-out look to it.

Pile: By folding part of the carpet in half, back to back, you can see if the tuft of wool has been inserted into a foundation or knotted onto warp threads. Sometimes designs are stamped onto a pre-woven pile surface and the colors only go partially down the individual strands of yarn.

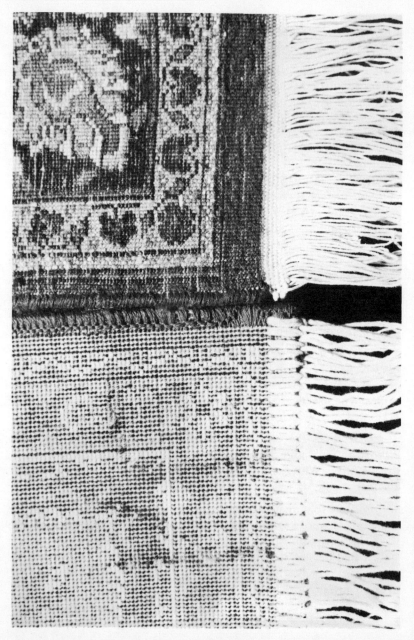

Plate 16. Compare the back, selvedge and fringe of the machine-made carpet on the top with those of the hand-knotted carpet on the bottom.

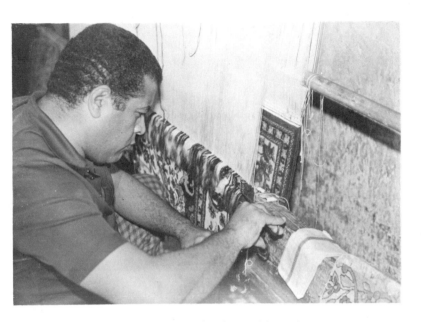

Plate 17. Trimming the pile of a hand-knotted carpet.

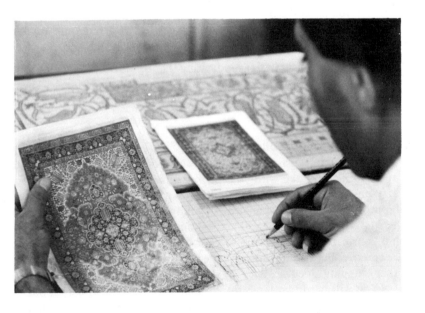

Plate 18. Producing a pattern board from a picture of an Oriental carpet.

6 How and Where to Shop for Egyptian Carpets

Shopping for a hand-made carpet could be the most interesting part of your stay in Egypt. During your search you will be seeing an aspect of life in Egypt that few people have even thought to look for. The more you look, the more you will learn.

If you are a resident, you will have more time to shop and compare before you buy a carpet. If you are a tourist and your time for carpet shopping is limited, this section of the guide will be very useful during your stay. Use it to help you find the shops most conveniently located to your hotel.

If you do not have your own car, it will be helpful to hire a taxi. The names and locations of the shops located in this Guide are written in Arabic in the appendix, so that you can show them to your driver. It is wise to negotiate the fare ahead of time on a per hour basis. Check with the reception desk of any hotel to find out the current rate. Also, be sure that both you and the taxi driver acknowledge the starting time of your excursion.

Many shops display signs indicating that prices are fixed. In shops without these signs, you may want to try your skill as a bargainer. There is no special formula or procedure for doing this and as long as you are polite, it doesn't hurt to try.

Taking a Carpet Out of Egypt
If you are a tourist, it is essential that you choose a rug which you can conveniently take with you, packed either in your baggage or as a carry-on item. It is extremely difficult to arrange for a carpet to be shipped from Egypt. Taking it with you is the best way of assuring that the carpet you purchased will arrive home safely. If you are a resident, ship your carpet with the rest of your household goods when you leave the country, but be sure you have the proper receipts to accompany your other shipping documents.

You will need two types of receipts to transport your carpet out of Egypt: a bank receipt and a sales receipt from the shop where you purchased the carpet. Since you must buy your carpet with Egyptian

pounds, exchange your foreign currency at a bank in the exact amount required to purchase the carpet. Have the receipt marked "for the purchase of a handmade carpet". This receipt, which shows that you have legally exchanged foreign currency, will have a number on it. Be sure this number is recorded on the receipt you get from the carpet shop.

When you enter your home country, you will probably have to pay customs duty on your carpet. Since customs rates and regulations change frequently, they are not quoted here. If you are a tourist, check with customs officials in your own country before your trip. If you are a foreign resident, you can check with your country's embassy or consulate in Cairo or Alexandria. Be sure to calculate the cost of any customs charges into the price of the carpet when you buy it.

Before you Buy

In recent years, hand-knotted rugs have received publicity as potentially good investments. Investing in carpets is a risky business done by experts who buy antique and semi-antique carpets. The purchase of any modern, commercially-produced knotted carpet should be considered as a decorating expense and not an investment. Even if their prices increase over the coming years, as world inflation rises, they are unlikely to have the resale value of the antique and semi-antique carpets.

If you have time, visit at least two shops before you buy. This will enable you to compare prices and quality. Since many shops are small and have a limited display area, you will be shown individual rugs from large piles of carpets which are stacked according to size. Deciding what size carpet you are interested in purchasing will save you time.

As you are examining these carpets, remember that each one will have some imperfections, as might be expected of a hand-made product. But if you find a particular flaw displeasing, choose another carpet even if you are told that the value of the carpet is not affected.

Below are a list of questions which will help in choosing the carpet that is right for you. Answer them either by questioning the shop keeper or by examining the carpet yourself.

Does the carpet lie flat? Sometimes, either as a result of uneven knotting or warping tension, the selvedges and the surface of the carpet may buckle. In addition to being unsightly, this will cause the carpet to wear unevenly.

Are there any stains, tears or moth holes? Ask the shop owner to take the carpet outside where the light is better, so you can examine both

67

the front and the back of the carpet. Repair patches are sometimes more visible from the back.

Is the carpet made from imported or domestic wool? For any flat woven rug, the answers will undoubtedly be Egyptian wool or "souf Masri". Be sure that the wool looks clean and does not feel greasy or scratchy. With hand-knotted carpets, the answer may be imported or domestic wool. Some carpet dealers use the term "tops", which indicates fine quality wool which has been spun for use in carpet making. Other terms such as "souf Ingleezi" (wool from England), or "souf Newzelandi" (wool from New Zealand) may also be used. The higher cost of imported wool is likely to affect the cost of a carpet.

Is the carpet mothproofed? Many dealers treat their carpets for export with a chemical substance called Eulan. This chemical is guaranteed to protect the carpet against moths for twenty-five years. If the carpet has been mothproofed, there should be a small black tag with a picture of a hand sewn onto the back of it.

Fig. 39. The Wool Mark is the logo for the International Wool Secretariat, a non-profit organization based in London. Active in Egypt since 1980, the goal of IWS is to promote the use of raw wool by providing a number of technical and marketing services to textile, clothing and carpet manufacturers. When you see the wool mark on a hand made Egyptian carpet it is your assurance that the carpet is made with one hundred percent wool, the dyes are colorfast and the oil content of the wool is appropriate.

Fig. 40. The design which appears on labels of carpets woven in Mehalla el Kobra.

Is the rug regular in shape, or misshapen? Because knotted and flat woven carpets are handmade, they probably will not be perfectly rectangular. However, the shape of the carpet should not detract from its overall appearance.

Will the carpet's colors run or fade? In Egypt, reputable makers of knotted carpets use dyes imported from Switzerland and Germany. Some of the flat woven rugs, however, such as the Bedouin carpets, are dyed with local dyes which are not light or water fast. To test the color fastness of the carpet, take a slightly damp piece of white cotton cloth and rub it over the carpet. No colors should be picked up by the cloth. Some dealers will give you a certificate of guarantee that the colors will not run or fade.

What does the back of the carpet look like? Looking at the back of a carpet will tell you if any repairs have been made. With a hand-knotted carpet, you can also tell how evenly the knots were tied, whether or not they are of uniform size and how clear the design is.

Each type of flat woven carpet has a characteristic appearance from the back. Kilim carpets and rag rugs, because of the way they are woven, are reversible. The backs of Bedouin carpets will have warp float threads and so can not be reversed. If the back of a flat woven carpet has many loose threads, it was probably done in a Soumak weave.

Are there any obvious, unattractive color changes? An abrash (an obvious color change) means that the weaver ran out of one dye lot and had to use another to finish the carpet. It should not affect the value of the carpet if it does not detract from its appearance. This effect is not as likely to occur in commercially produced hand-knotted carpets as it is in the flat woven carpets made by cottage weavers.

What does the fringe of the carpet look like? By looking at the fringe of the carpet, you can tell what kind of warp material was used. This will affect both the cost and appearance of the rug. Be sure that the fringe has been tied, with the warp threads separated into bunches and tied with an overhand knot.

If you are buying a rag rug, check the strength of the warp and the tightness of the weave by trying to poke your finger through the rug. If you can, it means the rug may fall apart after a few washings.

Taking Care of Your Carpet
Here are a few suggestions which should prolong the life of your carpet.

Padding. Using a pad protects both you and your carpet since it holds it in place as it is walked on. A pad will also reduce the amount of friction and wear on the back of the carpet. There are several different types of padding to choose from, including rubberized hair and jute, hair or felt backed, polyurethane foam, polyester net coated with specially cured vinyl, and sponge rubber. When choosing a pad, be sure to consider the type of surface the carpet will be covering. For example, there are special pads for rugs being placed on top of wall-to-wall carpeting. When buying a pad, choose one which will allow air to circulate, won't stretch, shed or produce toxic fumes if burned.

Cleaning Your Carpet. Both flat woven and hand-knotted carpets should be professionally cleaned. Experts differ in their opinion of how often this should be done. Some say it should be done every few years, while others say that once every five to six years should be enough. How often you clean your hand-knotted carpet will probably depend on how much you use it.

To keep your carpet clean at home, use a carpet sweeper every few days, then vacuum once a week. Using a broom may, over time, damage the carpet's surface. For hand-knotted carpets, clean in the direction of the pile. Don't be alarmed if this type of carpet fuzzes for the first several months.

With both types of carpets, turn them around every several months, so that they will wear evenly. Be sure to use carpet protectors under the legs of furniture.

To clean silk carpets, use a brush with medium soft bristles to brush in the direction of the pile, or just gently shake the whole carpet.

Spills. When you get your carpet home, it may be a good idea to collect all the things you need to clean up spills and put them in a caddy of some kind. This will enable you to clean up spills immediately. Plain soda water is good for removing many kinds of stains. For animal stains, first blot the stain and then use a solution of mild detergent and white vinegar. Don't get the spot too wet, since it may cause mildew or distort the carpet's shape.

Carpet Repairers. Egypt has some of the most skillful carpet repairers in the world. To repair a carpet, the worker dyes yarn to match the existing colors and then reknots the worn area. If the work is carefully done, it will be difficult to detect the repair.

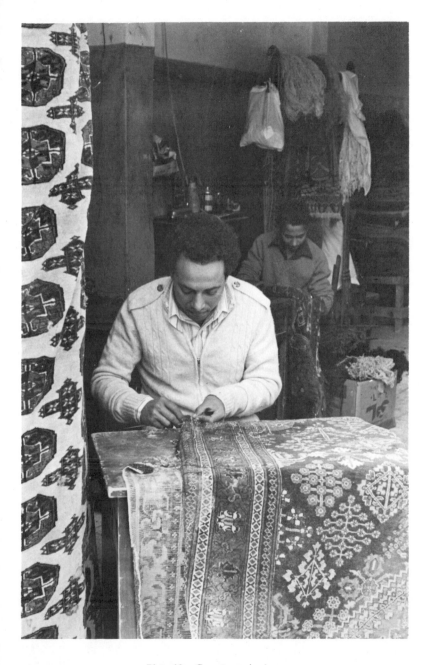

Plate 19. Carpet repair shop.

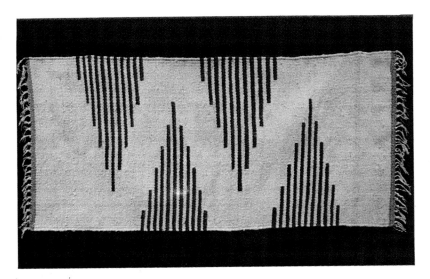

Plate 20. Helwan kilim.

Plate 21. Rag rug.

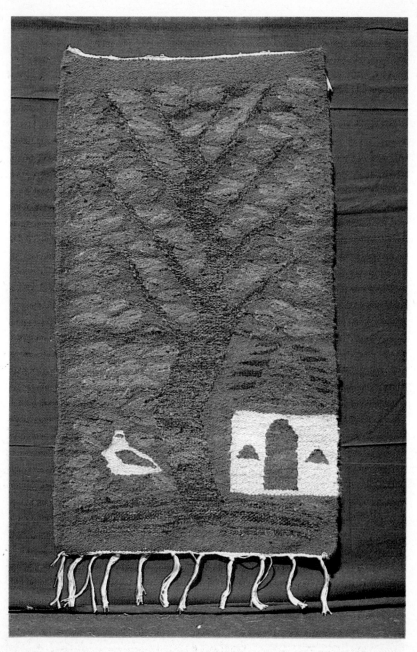

Plate 22. Tapestry.

Plate 23. Saddle blanket made with camel hair.

Plate 25. Detail of a tapestry produced at the Ramses Wissa Wasset Art School. —>

Plate 24. Hand-knotted wool carpet with cotton warp; Kashan design, with thirty-six knots per square centimeter.

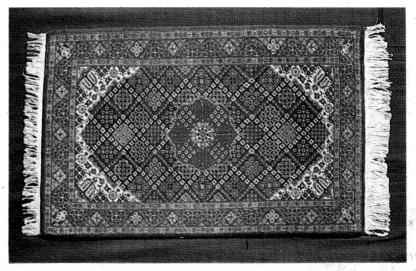

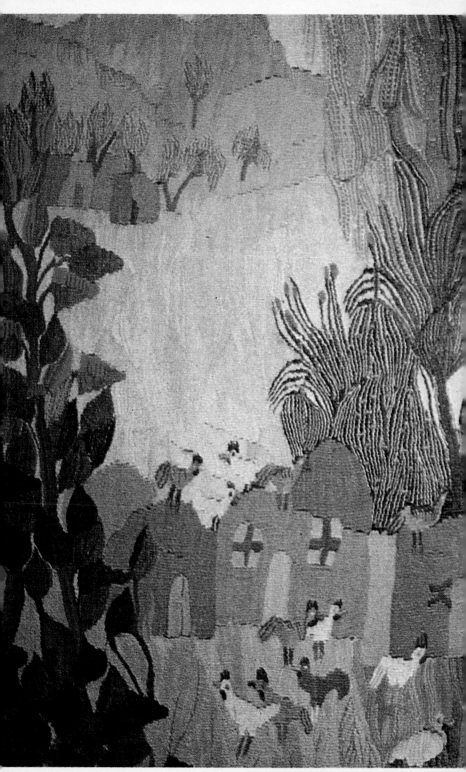

Plate 25

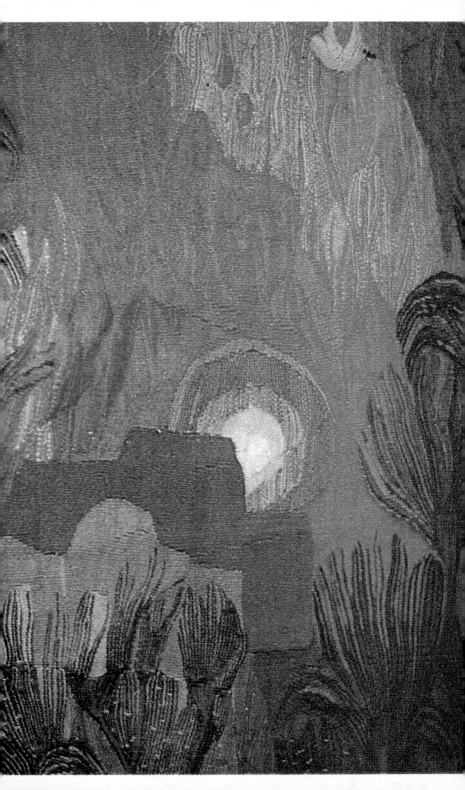

Plate 26. Bedouin carpet.

Plate 27. A woman weaving a Bedouin carpet near Borg el Arab.

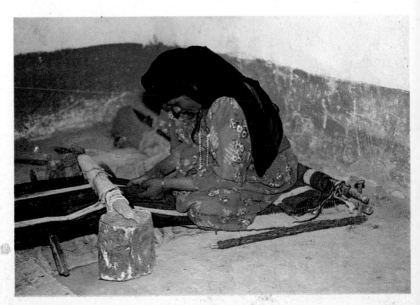

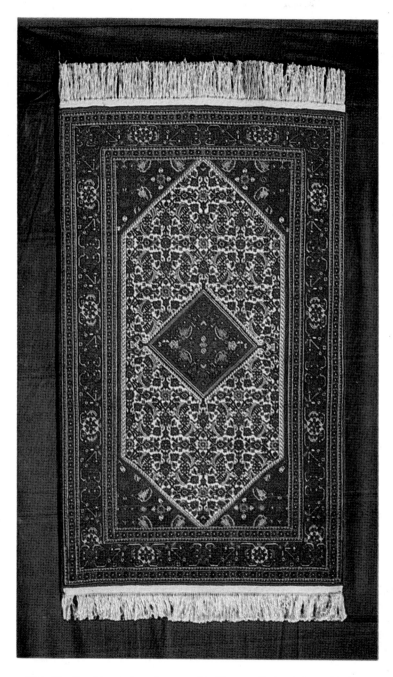

Plate 28. Hand-knotted wool carpet with silk warp; Senna design, with sixty-four knots per square centimeter.

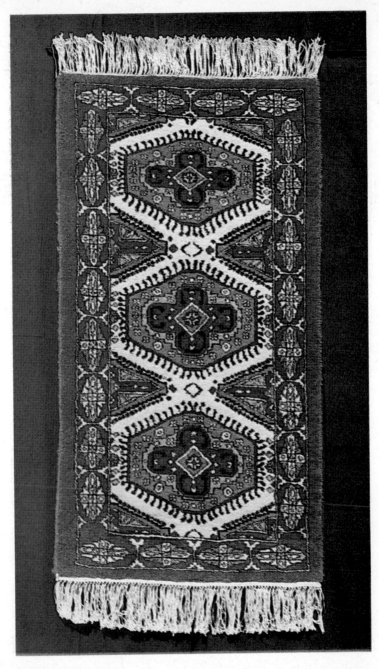

Plate 29. Hand-knotted carpet in natural shades of Egyptian wool. Thirty-six knots per square centimeter.

7 Carpet Shops in Egypt

The following chapter contains descriptions of many of Egypt's most accessible carpet shops. The majority of these stores sell carpets that are produced by the owner or made to the owner's specifications.

It would be impossible to list all of the carpet shops in Egypt, but with the information contained in this book, you should be able to judge for yourself whether a carpet is of good quality, no matter where you find it. The shops are arranged in the following order:

> The Khan el Khalili Area
> Downtown Cairo and Zamalek
> Outskirts of Cairo
> Alexandria and Surrounding Areas

Good luck and happy hunting.

Khan el Khalili Area

Name: El Kahhal.
Location: Khan el Khalili (Map 1, No.1) and Nile Hilton Courtyard.
Type of Carpet: Hand-Knotted, Kilims, Tapestries.

The El Kahhal carpet business was started a hundred and fifty years ago when a Syrian ancestor started importing Persian carpets to Egypt. The Kahhal family continued trading in Persian rugs until the Revolution in 1952 when all importation stopped. Experience in the carpet business had taught them about hand-knotted carpets. With this knowledge they started producing exact copies of Persian, Turkish and Caucasian rugs thirty years ago. The business is now run by Mr. Mohamed El Kahhal and his two sons, Abdallah and Mahmoud.

The Kahhal factory, in Basateen near Cairo, is large and well run. Fifty looms are set up at the factory to produce hand-knotted carpets. The weavers are generally men, some of whom have grown up working at the factory. Modern spinning machinery spins New Zealand wool into yarn according to their specifications. The yarn is dyed at their factory with Swiss dyes and after they are finished the carpets are given

an Oriental wash to make the colors softer (see Chapter 5). Since the wool is spun and dyed at their factory, the Kahhals have great control over the quality of the finished product.

The Kahhals sell a large variety of carpets in their shops, but they specialize in high quality wool hand-knotted carpets which are faithful copies of Persian rugs. You can find designs and color combinations at Kahhal's that you will not find elsewhere in Egypt. They also carry a selection of kilims and tapestries.

Both of Kahhal's shops are easy to find. One is in the courtyard of the Nile Hilton. A loom is set up in the window and a girl is usually working on a silk hand-knotted carpet. This provides a good opportunity to see how hand-knotted carpets are made. The other shop is in Khan el Khalili. Both shops are stocked with a good variety of carpets, and if you only have a short time to look for a carpet be sure to visit one of them.

Name: Wafik Ismail Ali.
Location: Khan el Khalili (Map 1, No. 2).
Type of Carpet: Variety.

This shop was started by Ismail Ali, the grandfather of the current owners, and is a completely separate business from the Ismail Ali carpet shop in Opera Square, although the two businesses are run by relatives.

The Ismail Ali family is one of the oldest importers of Persian carpets in Egypt, and has recently started producing their own carpets. The carpets sold in their shop are produced either in factories or private homes. The yarn for the hand-knotted carpets is purchased already dyed. There are not that many carpets in stock and some of them seem to be incomplete. The entrance to the showroom is covered with an exhibit of papyrus which is also for sale.

Name: Carpet Technical Company (Moussa Brothers)
Location: Khan el Khalili and 7 Mansouria Street, El Darassa, Cairo (Map 1, No. 3).
Type of Carpet: Variety.

This business was started by Mohamed Moussa who worked for the Ismail Ali family in their factory cleaning carpets. After the Revolution he started a workshop to clean carpets, and in 1962 he started a factory to produce carpets. The family has a shop in Khan el Khalili where there

is a large selection of kilims, Bedouin saddle bags, and tapestries as well as some hand-knotted carpets. The showroom in Darassa deals exclusively with hand-knotted carpets. The carpets which they sell are made in their workshop or purchased from weavers whom they know. Since the shop in Khan el Khalili deals with tourists, kilims and tapestries are stocked in large quantities. If you are interested in a hand-knotted carpet you should walk to the showroom in Darassa, which is close by.

Name: Sayed el Batie Aly Hassan.
Location: Khan el Khalili Area, 25 el Gamali Street, El Darassa, Cairo (Map 1, No. 4).
Type of Carpet: Helwan Kilims, Tapestries.

Sayed el Batie Aly Hassan exports numerous Helwan kilims and tapestries to Switzerland and West Germany. Many German and Swiss visitors go directly to him to buy kilims. The majority of the kilims and tapestries are produced in Fowa, a small village in the Delta area. He deals mostly in Helwan kilims which are one hundred percent wool and often mothproofed. The designs are geometrical and linear.

Sayed el Batie Aly Hassan does not really have a showroom, but a small workshop with five looms in the front room and an office in a back room where kilims and tapestries are stacked along the wall until they are packed to be exported. The workshop is located off of a narrow passage opposite the Moussa Brothers showroom in Darassa.

Downtown Cairo and Zamalek

Name: Abdou Moustafa.
Location: Downtown Cairo, 21 Sherif Street.
Type of Carpet: Wool Hand-Knotted Carpets.

This shop is located in downtown Cairo and it is owned and operated by Mr. Mahmoud Abdou Moustafa and his family. Mr. Abdou Moustafa studied weaving in a technical school in Tanta and when he graduated moved to Cairo where he worked for Kazarouni, a well-known dealer in Persian rugs. He repaired Persian carpets, which involved reweaving worn sections of carpets. Through his repair work he learned how hand-knotted carpets were made. After the Revolution in 1952, he opened his own store for repairing carpets and started a small workshop where he made hand-knotted carpets. He was successful and expanded his

business, moving to the location on Sherif Street in 1968. He is now one of the largest producers of hand-knotted carpets in Egypt.

Through contact with West Germany, where many of his rugs are sold, Mr. Abdou Moustafa has learned what type of carpets appeal to foreigners and has standardized his procedures to produce a high quality hand-knotted carpet. He has many weavers scattered throughout the Delta area working for him, with no more than one hundred and fifty concentrated in one place. He provides the weavers with dyed yarn and designs. The yarn is spun from New Zealand wool and dyed with Swiss dyes. He also provides some of the smaller carpet manufacturers with yarn. The finished carpets are given a chemical wash which mutes the colors.

Most of the carpets sold in this store are hand-knotted carpets made with imported wool and woven in Persian floral designs. The majority have thirty-six knots per square centimeter with cotton warps and measure one-and-a-half by two meters. The colors used are generally dark blue and red.

Name: Ibrahim Hussein.
Location: Downtown Cairo, Arabesque Restaurant, Kasr el Nil Street.
Type of Rug: Tapestries.

Ibrahim Hussein is an artist who creates designs for tapestries. After receiving his Bachelor of Fine Arts degree ten years ago, he set up a few looms in his family's workshop where towels have been woven for the past three hundred years. Muted colors are woven into designs which reflect Islamic and Pharaonic influences. Each tapestry is woven under his supervision and is signed. No more than five copies of each design are made.

His tapestries are more expensive than souvenir tapestries since they are original designs. They are exhibited at the Arabesque Restaurant on Kasr el Nil Street near Tahrir Square.

Name: Ismail Ali.
Location: Opera Square, Cairo.
Type of Carpet: Hand-Knotted.

Ismail Ali came to Egypt from Persia in 1887 and established a business importing Persian carpets. In 1952, when imports became difficult, his descendants started producing carpets, using workers who had

previously repaired carpets for them. Because of their experience with Persian carpets, they were able to produce high quality hand-knotted carpets.

Recently, the family business has been divided between two brothers. One has taken the shop in Khan el Khalili which was described earlier, while the other has the shop in Opera Square. Although they share the name of Ismail Ali the two businesses are completely separate.

The shop in Opera Square is owned and operated by Mr. Zaki Ali Ismail, his son and two daughters. They have a large selection of beautiful Persian design hand-knotted carpets. The majority of their carpets are produced in factories; only ten percent are produced in private homes. Most of the carpets are made with imported wool dyed with Swiss dyes which they order to their specifications. Workers who have been with the family for twenty-five to thirty years teach and supervise new weavers. At the shop you can find all qualities of hand-knotted carpets in a variety of Persian floral designs in beautiful color combinations. All of their carpets are exact reproductions of Persian carpets that have passed through their hands at one time. They stock a large selection of beautifully woven silk carpets. If you are looking for a silk carpet be sure to visit their store.

The shop is located on Opera Square next to the entrance of the Continental Hotel.

Name: Kelim.
Location: 3 Dr. Fouad El Ahawani Street, Zamalek (Map 2).
Type of Carpet: Variety.

Kelim is run by Ismail Alfi to sell carpets produced by his father, Hussein Alfi. There is a large variety of carpets available at this shop, including silk carpets, wool hand-knotted carpets (some with silk warps), and a large variety of kilims. Mr. Alfi is continually looking for ways in which to improve his production and to develop new products. One product of his experimentation is a type of large cushion made from kilims.

During the 1960s Hussein Alfi bought a spinning factory and started producing hand-knotted carpets and kilims. He buys local wool which he washes and spins in his own factory. He uses the yarn to make Helwan kilims. Looms are set up on the second floor of the factory where kilims and hand-knotted carpets are woven. His hand-knotted carpets are woven with imported wool dyed with foreign dyes and are

guaranteed colorfast. He has a wide variety of high quality Helwan kilims and hand-knotted carpets.

The shop is located in Zamalek in a side street that runs parallel to Shagaret el Dor Street, near the Zamalek Bookstore. If you are looking for a carpet in Cairo you should stop at this shop.

Outskirts of Cairo

Name: Ramses Wissa Wassef Art School.
Location: Haraneya, a village on the road to Saqqara.
Type of Carpet: Tapestries.

The Ramses Wissa Wassef Art School produces some of Egypt's most famous art. The tapestries created by the weavers at this school range from simple reflections of rural Egyptian life, produced by younger weavers, to the fluid, almost impressionistic creations of the older weavers who are rightfully called artists. Shows in many countries, including France and Switzerland, have given the school a well-deserved worldwide reputation.

These tapestries, which are woven on vertical looms, are made from pure Egyptian wool. The soft pastel colors, which come from vegetable dyes, are created by Madame Sophie Habib Ghorgy, who founded the school over thirty-five years ago with her husband, the late Ramses Wissa Wassef. A few small pieces are made with both linen warp and weft.

Weaving is done from side to side. This technique seems to give the artist the ability to weave the flowing lines of color which are so distinct in this school's tapestries. The Wissa Wassef Art School has had a significant impact on the entire Egyptian tapestry industry. Once you have seen the pieces made at the school, you will realize that many tapestries sold in Kerdassa and other parts of Egypt are copies of Wissa Wassef designs.

As a young man, Wissa Wassef studied architecture in France and first saw the famous Gobelin tapestries. When he returned to Egypt, he combined his appreciation of these tapestries with his desire to help the poor of his country by starting the school. He felt that children, by mastering a difficult task such as tapestry weaving, would gain a sense of accomplishment and self-confidence that would carry over into other aspects of their lives.

He also believed that children have a unique ability for creating art, and that for this ability to be fully developed children must be protected

from outside influences which would change their innocent view of life. Thus, when new students begin their weaving careers around the age of ten, they are kept separate from the older weavers so they will not be indirectly influenced. Criticism or suggestions from adults and other weavers are not allowed. Poetry and stories are sometimes read to the children to inspire ideas for new tapestries, for, according to Madame Ghorgy, each tapestry has a story to tell. Walks through the country are sometimes arranged for the children so they can observe how shapes and colors occur in nature.

The secret of the school's success seems to be their ability to retain weavers over a long period of time by treating each weaver as a member of the family. The years of training and encouragement received by the older artists are reflected in their brilliantly conceived and beautifully executed pieces.

The school also carries on the work of Habib Ghorgy, Madam Sophie's father, a famous sculptor known as the "lover of children". He too believed "every child is born an artist", and would bring other children into his home to live with his family. There he taught them to work with clay. In addition to its lovely museum, the school has a special section which produces beautiful sculptured figurines portraying traditional Egyptian characters. Some pottery dishes are also made. The work of Saida Mesak, an artist trained by Habib Ghorgy, is for sale at the workshop.

The design of the school complex reflects the architectural skill of Ramses Wissa Wassef. The ingenious use of domes has created a setting which is peaceful and fits naturally into the surrounding countryside.

The soft light in the school gallery, created by spotlight-shaped holes in the domed ceiling, is perfect for displaying the larger works of art. Many of the pieces on display are part of the school's collection and are not for sale. Other pieces are priced as original works of art.

If you visit this school, you will find the weavers eager to show you their work and you will leave with a greater appreciation for the skill that goes into creating these works of art.

To get there, take the road to Saqqara and go a few kilometers past the Darwish Pottery Museum. Turn to the right at the first gas station. (There is a sign saying Drexel, where you should turn.) Drive over a small bridge and turn right again. The gate to the school is a few yards down.

Name: Atelier des Pyramides (Studio of the Pyramids).
Location: El Batran, a small village outside Giza.
Type of Carpet: Tapestries.

The tapestries produced by the young weavers at the Atelier have a refreshingly innocent quality. They are made from one-hundred percent Egyptian wool weft which has been commercially dyed, and the warp is one-hundred percent Egyptian cotton. Scenes from Egyptian rural life are the subject of many pieces.

Tapestries from the Atelier have been shown in many countries including England, France and Holland. The Atelier was founded by Dr. Amir Aly, a professor of cinematography at Helwan University. He has always been interested in Egypt's folk art, and for many years has collected samples of Egyptian crafts, such as carpets, jewelry and clothing, from all over the country. He realized that the skills needed to continue these creative traditions were not being passed on to younger Egyptians and became worried that his countrymen were losing part of their artistic heritage.

Dr. Aly decided to concentrate on preserving the ancient tradition of tapestry weaving, which dates back thousands of years in Egypt. He started the Atelier in the late 1960's and modelled it to a certain extent on Wissa Wassef's school in nearby Haraneya. In 1968, he went to Paris to complete his Ph.D. in cinematography, leaving the studio under the supervision of his sister. He returned to Egypt in 1974, and moved the studio to its present location in 1978.

Dr. Aly believes that Egyptians are artists by instinct, and that this instinct should be developed from an early age. Many children from the surrounding village of Batran come to the studio out of curiosity. The children who stay must be willing to discipline themselves and work hard. New weavers are shown the basic techniques of tapestry weaving and left to master them with the guidance of older workers.

Ideas for the tapestries come from the children's imagination and are worked directly onto the loom. Designs are not drawn on paper first. Work starts at the bottom of the piece and progresses upward. Dr. Aly provides a variety of experiences, such as trips, to expose the children to new images and ideas. Although he talks with the weavers on a daily basis about their work, he tries not to influence their creative decisions. One of his main concerns seems to be to provide an enriching experience for these children.

The weavers' education in other areas is not neglected. A teacher visits the studio regularly and gives lessons in history, reading, writing and religion. Health care is also provided. One of the problems that the

studio continually faces is the loss of highly skilled girls who leave their work around the age of sixteen to marry. This cultural tradition has decreased the number of older workers, who produce more visually mature pieces.

The Atelier is well worth a visit. You will be impressed by the peaceful atmosphere that Dr. Aly has created. Since future plans for the studio include inviting foreign and Egyptian artists who work in other mediums to use the creative climate of the Atelier, you may be able to see other types of art as well.

Prices of the tapestries produced here are higher than those which can be purchased at Kerdassa and other mass production outlets, but since these pieces are original works of art, the higher cost is justified. Proceeds from the tapestry sales are used to maintain the studio and to pay the wages of the weavers, some of whom earn as much or more than many college graduates.

If you would like to meet Dr. Aly on your visit, he is there almost every Friday. To reach the Atelier from Cairo, take the Pyramid Road and turn left onto Zagloul Street, the road after the turn-off to Saqqara. Go a few kilometers more and stop at the Tomb of El Sitt Nassra. You will have to stop and ask where these landmarks are since none of them is marked. It is best to park off the main road near the tomb and walk down the narrow lane to your left. As you pass the last apartment building the Atelier will be on your left. Your efforts in reaching the Atelier will be worthwhile as you meet the children and enjoy Dr. Aly's hospitality.

Name: Kerdassa.
Location: Small village outside Giza.
Type of Carpet: Tapestries, Kilims.

Kerdassa is a small village on the outskirts of Giza. In 1976 there were only two shops which sold tapestries and kilims produced in their own workshops. It was popular with tourists since they could buy tapestries and rugs and, at the same time, see how they were woven. In a few years Kerdassa has been transformed into a second Khan el Khalili and souvenir shops line the main street, vying with each other for the tourist trade. In spite of the competition, there seems to be a tradesmen's agreement on minimum prices for certain items.

The carpets and tapestries sold in Kerdassa are produced in many areas of Egypt. Looms are set up in the front of some of the older shops and you can see how the tapestries and kilims are woven.

Since its beginning Kerdassa has specialized in tapestries modeled on the Wissa Wassef tapestries, and there is quite a large selection to choose from. You can also buy copies of the Wissa Wassef tapestries whose photographs have appeared in different books. For this reason the Wissa Wassef family does not allow photographs to be taken of the new tapestries.

The different shops in Kerdassa also carry a large selection of kilims and some Bedouin carpets and saddle bags. The quality varies greatly so check everything carefully before you buy it.

To reach Kerdassa, take the Pyramid Road until you see the large sign on the right for Andrea's Restaurant. Turn right along the canal. After aproximately six kilometers you will see a road to the left which is lined with shops—this is Kerdassa.

Alexandria and surrounding area

Name: Mehalla el Kobra Cooperative Society for Cottage Industries.
Location: Mehalla el Kobra, near Tanta, in the Delta.
Type of Carpet: Hand-Knotted.
Sold In: Hannaux, Salon Vert (Kasr el Nil Street, Downtown Cairo).

The Mehalla el Kobra Cooperative Society for Cottage Industries produces some of the nicest hand-knotted carpets in Egypt. It was started twenty-five years ago to teach children of employees of the Misr Spinning and Weaving Company, one of Egypt's largest public sector textile companies, a skill with which they could make a living.

The Cooperative Society employs approximately two thousand workers. Half of them embroider handkerchiefs and bed linen as well as needlepoint French Aubusson designs; the other half are employed in the carpet making section of the Society. At the age of twelve children start learning how to hand-knot carpets, but they are not considered professional weavers until they reach the age of eighteen. During the training period, they are paid a small salary, but at the age of eighteen they receive a standard wage, which is higher than the average national wage. Many other benefits are offered to weavers, such as health care, company housing when available, and day care for children.

All of the carpets produced in Mehalla el Kobra have a wool pile. A few of them have silk accents, but as yet no silk carpets are produced. The carpets are made from the highest quality Egyptian wool, which is blended with wool imported from New Zealand, Australia, and England.

Approximately ninety percent of the materials used in making the carpets come directly from Misr Spinning and Weaving Company, including the wool, which has been spun and dyed to the Society's specifications. Dyes are Swiss and West German and are guaranteed colorfast. Carpets are made in a range of attractive color combinations.

Most of the patterns are taken from Persian carpets. Some original designs, based on the Persian style but with Egyptian motifs such as Pharaonic figures, are also being used.

The factory is located in Mehalla el Kobra, a town near Tanta in the Delta area, but the carpets are sold in the government department stores, such as Salon Vert and Hannaux, in the household furnishings department. You will recognize the carpets from the label (fig. 43).

Name: Loutfi Moustafa and Sons.
Location: Alexandria: 22 Chamber of Commerce Street; 39 Omar el Mokhtar Street, Gianaclis (Map 3).
Type of Carpet: Variety.

Loutfi Moustafa has been in the carpet making business since 1930, when he graduated from the Mohamed Aly School of Industry in Alexandria. He began producing carpets in his home and eventually opened his own shop. His sons Moustafa, Mohamed and Mahmoud now work with him.

Loutfi Moustafa is one of the few weavers in Egypt who produces hand-knotted carpets with his original designs based on Egypt's Pharaonic past.

Carpets sold in his shop are produced in the homes of weavers living in the Delta area south of Alexandria. Many of these families have been working with Mr. Moustafa for many years. He provides them with all the material needed for making a carpet. The finished carpet is then purchased at a predetermined price. Loutfi Moustafa is very concerned with the quality of his carpets and deals only with people whom he knows, after years of experience with them, are trustworthy. He sells all types of rugs in his shop. One of his specialties is high quality Helwan kilims of pure wool. The designs are attractive and he carries all sizes from two by three meters to the small throw size. Another specialty is hand-knotted carpets with his original Egyptian designs. These rugs are woven in thirty-six or forty-nine knots per square centimeter with local wool in natural colors.

There are two shops in Alexandria. The main one is downtown on Chamber of Commerce Street (the tram street) on the right side of the

street going towards Manshia from the Cecil Hotel. The other shop is in Schutz.

Name: Masged el Hadeya (Hadeya Mosque).
Location: Alexandria: Sharia Masged el Hadeya, Boulkley (Map 4).
Type of Carpet: Kilims, Hand-Knotted Carpets.

This is a charitable organization which produces both kilims and hand-knotted carpets in a mosque in Alexandria. It used to be a birth control and medical care facility but was changed into a carpet factory in an effort to keep the craft alive. All of the income goes to the upkeep of the mosque.

This is a large three-storey facility. On the first floor, kilims are woven by young men and on the second and third floors young girls work together on hand-knotted carpets. The workers are usually young girls who are not able to finish school and want to learn a craft. All types of hand-knotted carpets are produced with either imported or Egyptian wool. The designs are taken from catalogues and transferred to graph paper. There is a large variety of hand-knotted wool carpets, tapestries and kilims. The kilims and tapestries are woven with thin wool weft and cotton warps.

The mosque is on Masged el Hadeya street near the tram. Going towards the sea from Horreya, you will see a mud-covered building on the right. The entrance is on the side. They are very helpful, and they will show you around the workshop if you are interested in seeing how the carpets are made.

The carpets are kept in the prayer area of the mosque and you must take your shoes off before entering. Carpets are not sold on Friday.

Name: George Haddad.
Location: Alexandria: 46 Safia Zaghloul Street.
Type of Carpet: Kilims, Hand-Knotted Carpets.

In 1958 George Haddad started producing hand-knotted wool carpets and four years ago he started producing silk carpets. His specialty is Helwan kilims which he exports to Europe.

Mr. Haddad has a factory outside of Alexandria where some of his carpets are produced. Others are produced in Fowa with yarn which he provides. Since Mr. Haddad's business is mostly export, only a very small stock of his carpets is kept at his store. The majority of rugs stocked are machine-made, but there are also a few hand-knotted

carpets. If you are interested in buying a Helwan kilim ask to see his catalogue from which you can order rugs according to size and design which will be ready within two to three weeks. He has a wider choice of designs in Helwan kilims than is offered in other shops.

The shop is located in downtown Alexandria on the corner of Safia Zaghloul Street and Sultan Hussein Street next to a newsstand.

Name: Rachid Carpets.
Location: Alexandria: 474 Horreya Street, Rouchdy; 187 Ahmed Shawky Street, Rouchdy (Map 5).
Type of Carpet: Hand-Knotted Carpets, Assyuti kilims, Tapestries.

The Rachid carpet shop is owned and operated by the El Hawaga family who are originally from Rachid, a city in the Delta near Alexandria. They carry a large selection of hand-knotted carpets in a variety of designs.

The carpets sold in this shop are produced in the city of Rachid where there are approximately five hundred looms, most of them in private homes.

Rachid carries a wide selection of hand-knotted carpets with Caucasian, Persian and Turkish designs. If you are in Alexandria and want to buy a hand-knotted carpet, you should see what they have to offer here. There is a large stock on hand but you have to be patient when looking for a rug since the shop is disorganized. The shop in Ahmed Shawky Street has the larger selection of hand-knotted carpets, but these may be concealed behind linoleum and machine-made carpets stacked in the entrance way. The saleswomen are helpful but speak little English.

Name: Abdel Satar El Hanafi.
Location: Alexandria: 77 Moustafa Kamel Street (Map 6).
Type of Carpet: Assyuti kilims, Rag Rugs.

Abdel Satar el Hanafi started weaving rag rugs in 1945. His father, a cotton merchant in a small village near Assyut, went bankrupt during World War II when the exportation of cotton was prohibited. Abdel Satar, a teenager then, left school and went to Alexandria where he worked for several textile firms, the last of which was a T-shirt factory. He set up his own loom and in his spare time wove rag rugs with T-shirt scraps from the factory. He did well enough to start his own business

and now has a shop in Alexandria where he sells a large variety of rag rugs and Assyuti kilims.

The majority of Abdel Satar el Hanafi's rag rugs are woven on looms in private homes with cotton scraps which he provides. He was one of the first to start using cotton T-shirt fabric for rag rugs and this has continued to be his specialty. The large variety of rag rugs which he carries are produced by his weavers in many designs: checkerboard, broad stripes, and solid colors. They are of good quality and machine washable. He also carries a large selection of Assyuti kilims in primary colors with interesting designs, from Assyut or Fowa, a town in the Delta.

The shop is located at 77 Moustafa Kamel Street in the Fleming district of Alexandria next to a café whose sidewalk is elevated. Rugs are stacked everywhere and it may take time to find the rug you want. Both Mr. Hanafi and his salesman are helpful but they do not speak much English.

Name: Hammam.
Location: 65 Kilometers West of Alexandria along the Coastal Road.
Type of Carpet: Western Coastal Bedouin Rugs.

Hammam is a Bedouin town set on the edge of the desert which is a market place for the Western Coastal Bedouins, and you can buy their rugs there. Little English is spoken and tourists may find that they have attracted a crowd who follows them everywhere. Women should dress conservatively.

Rugs, produced by Bedouin families around Hammam, are brought there when finished to be sold in stores which sell fabric, clothing, and blankets. The rugs are woven seasonally and during the spring you will find the best selection. In October the supply is low because the new weaving season begins then.

Two types of Bedouin rugs are sold in Hammam: warp face weave and Soumak weave. The colors and designs are attractive but the rugs often have imperfections. Examine each carpet carefully for holes and places where the dye has run before buying it. There is no set price in Hammam; they fluctuate with your ability to bargain and the mood of the store owner.

Hammam is between Alexandria and El Alamein. Turn south at the first police station after Borg el Arab (large fortress to the left). Follow a paved road for five kilometers and you will see a group of square stone buildings which is Hammam. Ask for the *souk* (market

place). The stores that sell rugs are located throughout the market area and are recognizable by the bolts of fabric which they also sell. Friday is not a good day to go since the stores are crowded with Bedouins who come in from the surrounding area to shop.

Alphabetical Listing of Carpet Shops in English and Arabic

Abdel Satar el Hanafi
77 Moustafa Kamel St.
Alexandria

Abdou Moustafa
21 Sherif St.
Cairo

Atelier des Pyramides
Batran

Carpet Technical Company
Moussa Brothers
Khan el Khalili and
25 el Gamali St.
Darassa, Cairo

El Kahhal
Khan el Khalili and
Nile Hilton Courtyard

George Haddad
46 Safia Zaghloul St.
Alexandria

Hammam
65 Kilometers West of
Alexandria

Ibrahim Hussein
Arabesque Restaurant
Kasr el Nil Street
Cairo

Ismail Ali
Opera Square
Cairo

Kelim
3 Dr. Fouad el Ahawani St.
Zamalek, Cairo

Kerdassa
Small village outside
of Giza

Loutfi Moustafa & Sons
22 Chamber of Commerce St. and
39 Omar el Mokhtar St. Gianaclis,
Alexandria

Masged el Hadeya (Hadeya Mosque)
Masged el Hadeya St.
Boulkley, Alexandria

Mehalla el Kobra Cooperative Society
for Cottage Industries
Mehalla el Kobra

Rachid Carpets
474 Horreya St. and
187 Ahmed Shawky St. Rouchdy
Alexandria

Ramses Wissa Wassef Art School
Haraneya

Sayed el Batie Aly Hassan
25 el Gamali St.
Darassa, Cairo
(near Khan el Khalili)

Wafik Ismail Ali
Khan el Khalili
Cairo

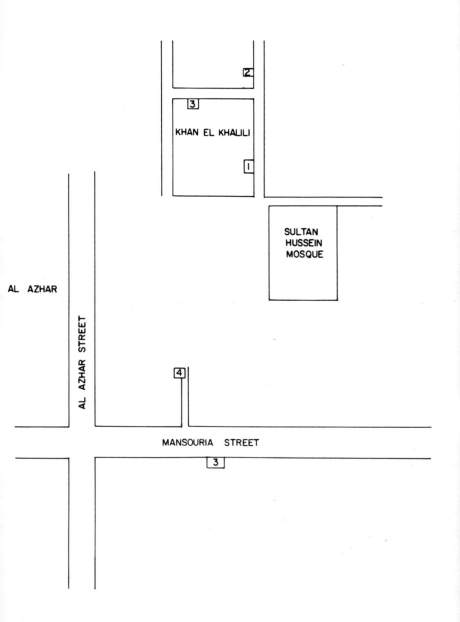

Map 1. Khan el Khalili

97

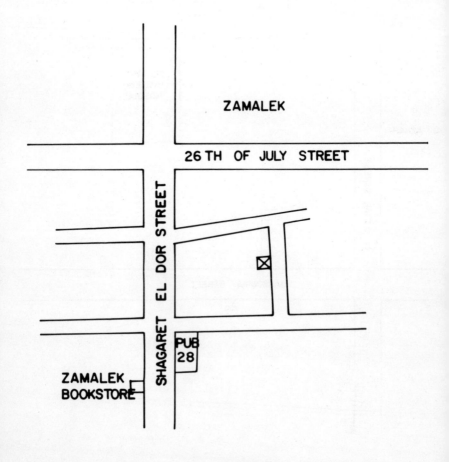

Map 2. Zamalek

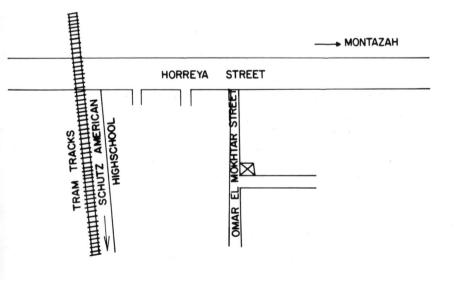

Map 3. Alexandria

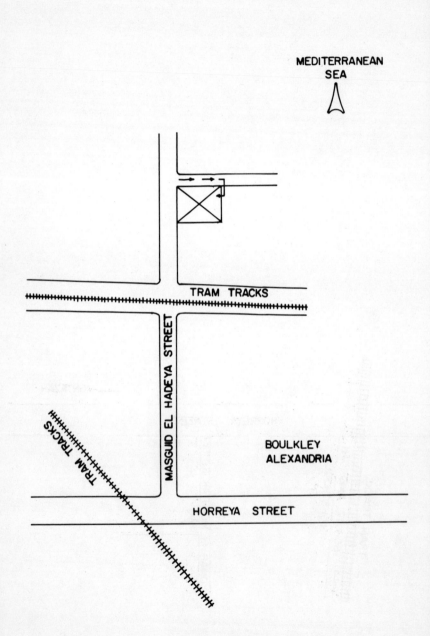

Map 4. Alexandria

Map 5. Alexandria

Map 6. Alexandria

Bibliography

Aldred, Cyril. **The Egyptians.** London: Thames and Hudson, 1961.

Bacharach, Jere L., and Bierman, Irene A., editors. **The Warp and Weft of Islam.** Seattle: Henry Art Gallery, The University of Washington Press, 1978.

von Bode, Wilhelm and Kuhnel, Ernest. **Antique Rugs from the Middle East.** Brauneschweig: Klinkhart, Bierman, 1958.

Budge, E.A. Wallis. **Dwellers on the Nile.** Second unabridged edition. New York: Dover Publishers Inc, 1977.

Dilley, Arthur U. **Oriental Rugs and Carpets.** Revised by Maurice S. Dimand. Philadelphia and New York: J.B. Lippincott, 1959.

Erdmann, Kurt. **Oriental Carpets: An Account of Their History.** Translated by Charles Grant Ellis. London: A. Zwemmer Ltd, 1960.

Erman, Adolf. **Life in Ancient Egypt.** Translated by H.M. Toranl. New York: Dover Publications Inc., 1971.

Fokker, Nicolas. **Persian and Other Oriental Carpets for Today.** London: George Allen and Unwin, Ltd., 1973.

Forbes, R.S. **Studies in Ancient Technology.** Volume IV, second revised edition. Leiden: E.J. Brill, 1967.

Formenton, Fabio. **Oriental Rugs and Carpets.** London: Hamlyn, 1972.

Hack, Hermann. **Oriental Rugs.** Edited and translated by George and Cornelia Wingfield. London: Faber and Faber, 1960.

Hall, A.R., Holmyard, E.J., & Singer, Charles. **A History of Technology.** Oxford 1954-56; the following chapters:
 Crowfoot, Grace. "Textiles, Basketry and Mats", Volume 1, pp. 413-447.
 Grant, Julius. "A Note on the Materials of Ancient Textiles and Baskets", Volume 1, pp. 447-451.
 Patterson, R.. "Spinning and Weaving", Volume 2, pp. 191-218.

Haris, Nathaniel. **Rugs and Carpets of the Orient.** London: Hamlyn, 1977.

Harris, J.R., ed. **Legacy of Egypt.** Oxford: Oxford at the Clarendon Press, 1971.

Hodges, Henry and Lane, Allen. **Technology in the Ancient World.** Penguin Press, 1970.

Holt, Rosa Bella. **Rugs Oriental and Occidental, Antique and Modern.** Chicago: A.C. McClurg and Co., 1908.

Hubel, Reinhard G. **The Book of Carpets.** Translated by Katherine Watson. New York: Prager Publishers, 1970.

Jones, David. **Islamic Art: An Introduction.** London: Hamlyn, 1974.

Justin, Valerie Sharaf. **Flat Woven Rugs of the World: Kilim, Soumak, and Brocading.** Van Nostrand, Reinhold Co., 1971.

Kuhnel, Ernest. **Cairene Rugs and Others Technically Related: 15th-17th Century, The Textile Museum Catalogue Raisonne.** Technical Analysis by Louisa Bellinger. Wash. D.C.: National Publishing Co., 1957.

Larson, Knut. **Rugs and Carpets of the Orient.** New York: Frederick Warne and Co., 1967.

Lucas, A. **Ancient Egyptian Materials and Industries.** Second edition. London: Edward Arnold and Co., 1926.

Mohamed Abdel Aziz Marzouk. **History of the Textile Industry in Alexandria 331 B.C.-1517 A.D.** Alexandria University Press, 1955.

Mumford, John Kimberly. **Oriental Rugs.** New York: Charles Scribner's Sons, 1902.

Petrie, W.M. Flinders. **Arts and Crafts of Ancient Egypt.** Second edition. London: edited and published by T.N. Foulis, 1910.

Reed, Stanley. **Oriental Carpets and Rugs.** Hong Kong: Octopus Books, 1972.

Wissa Wassef, Ramses. **Woven by Hand.** London: Hamlyn, 1972.

Weibel, Adele C. **Two Thousand Years of Textiles.** New York: Pantheon Books, 1952.

Magazine Articles

Brill, Maria L. "Rag Rugs". **Cairo Today** (November 1983): pp. 66-68.

Cavallo, Adolph S. "A Carpet From Cairo". **Journal of the American Research Center in Egypt,** I (1962): pp. 69-74.

De Unger, E. "The Origin of the Mameluke Carpet Design". **Hali** 2 (1979): pp. 40-42.

Gough, Sean. "The Mamluk Sultanate". **Hali,** 4 (1981) No 1.

Ibrahim Aly Pasha. "Early Islamic Rugs of Egypt or Fostat Rugs." **Bulletin de l'Institut d'Egypte,** XVII (1934/5): p. 123

Ittig, Annette, "Cairene Carpets—The Modern Industry". **Cairo Today** (December, 1982): pp. 45-48.

Lange. Mark T. "The Silk Story". **Cairo Today** (December, 1983): pp. 26-36.

Martiny, Alan. "Kerdessa: The Carpet Village." **Cairo Today** (October 15, 1980): pp. 3-5.

Trunzo, Candace E. "Take a Flyer on Oriental Carpets". **Money,** 10 (December 1981): pp. 124-126.

Serjeant, R. B.. "Egyptian Textiles". Chapter XVI of **Islamic Textiles, Ars Islamicas,** Vol. XIII-XIV, pp. 88-117.

Simmons, Virginia McConnell. "Warps, Wefts and Wadis". **Aramco World Magazine,** September-October, 1981.

Wiet, Gaston. "Tapis Egyptiens". **Arabica** 6, (1959): pp. 1-24.